IMAGES
of America

STONE MOUNTAIN

IMAGES
of America

STONE MOUNTAIN

Stone Mountain Historical Society

ARCADIA
PUBLISHING

Published by Arcadia Publishing
Charleston, South Carolina

Printed in the United States of America

Library of Congress Control Number: 2013938499

For all general information, please contact Arcadia Publishing:
Telephone 843-853-2070
Fax 843-853-0044
E-mail sales@arcadiapublishing.com
For customer service and orders:
Toll-Free 1-888-313-2665

Visit us on the Internet at www.arcadiapublishing.com

To the city of Stone Mountain in celebration of its 175th year.

CONTENTS

ACKNOWLEDGMENTS

Many individuals and families opened up their scrapbooks to share photographs that tell the story of their hometown, Stone Mountain. It is a story of small-town life that is made even more memorable for its bond with the mountain that shares its name. While the mountain captured the attention of the state, the nation, and the world for a variety of reasons, the village at its feet maintained its poise as a workingman's town, comfortable in its own skin. We hope these images capture that past.

We thank George and Susan Coletti, Kim Cumbie, JoAnn Florence, the Greene family, Dorothy Guess, Rusty and Ann Hamby, Evelyn Hearns, George Anne Hoffman, the Hollis family, Hugh and Betty Jordan, Peggy and Jerry Mills, Pauline Myers, the Ogletree family, Gary Peet, Jane and Ottis Phillips, Robin and Jane Rhodes, Becky and Mike Sanders, Tug Tuggle, the Wade family, and Madeline White.

The real and virtual walls of ART Station, the Stone Mountain Memorial Association, the City of Stone Mountain, and the Stone Mountain Woman's Club were all searched for images, with good results. Images from Georgia State University, Georgia Archives and History, the Hargrett Rare Book and Manuscript Library in the University of Georgia Libraries, and the National Archives are also included, and credited where they appear.

George Coletti, Sam Wade, Tug Tuggle, Ralph "Rooster" Spain, Rusty and Ann Hamby, Gary Peet, Dot Guess, Becky Sanders, and Charlotte Pittard deserve special thanks for helping with identifying individuals and events in the collected photographs. Jerry Mills brought to our attention the incredible 1903 series of photographs of the village in the National Archives, and we unabashedly made use of George Coletti's love of his hometown's history.

Finally, we salute photographers Robert Holley, John Fred Maddox, Jessie Wilson, Roy Mitchell, and others, who understood the importance of our history and captured it on film for us to enjoy.

INTRODUCTION

Word of Stone Mountain's compelling natural beauty had reached many Georgians by the 1830s. The adventurous made the journey by stagecoach or horseback, desiring to see firsthand the massive granite landmark and to scope the land that was swiftly being converted from Native American use into Georgia counties. Described in the *Macon Telegraph* in 1830 as a "stupendous pyramid" of "bold, naked rock," it did not disappoint. Some, feeling a kinship with the mountain's natural beauty or sensing economic opportunity, stayed and made their home at the growing frontier settlement established near its base. The mountain has been known by a variety of names: Thenneth Lofkee, Crystal Mountain, and Lone Mountain. Rock Mountain was its moniker prior to 1825, but, by the close of the 1830s, Stone Mountain had become the accepted name. Like the mountain, the village formed at its base was initially known as Rock Mountain. However, it was incorporated as New Gibraltar in 1839 under an act of the general assembly before being renamed Stone Mountain by an act of the legislature in 1847.

While the village was debating its name, a new factor came into play that helped forge its identity: the completion of the Georgia Railroad. In 1845, the future right-of-way that connected the Georgia Railroad with the Western & Atlantic's terminus in Marthasville (now Atlanta), to the west, bypassed the early settlement. This prompted Stone Mountain's forward-looking residents and investors to move the townsite to the east side of the newly laid railroad tracks, within Land Lot 89 of DeKalb County's 18th District. The railroad was the defining feature of the young village. Sandwiched between the railroad right-of-way and the mountain, it guaranteed commerce and prosperity, with its depot acting as the gateway to the landmark.

Investors were keenly aware of Stone Mountain's tourist potential. Cloud's Tower, built in 1838, was a perfect example. The viewing tower was built on the mountain's summit but wasn't anchored. Remembered largely for its sheer audacity, Cloud's Tower was a curiosity with a short lifespan, as a storm destroyed it in 1849. A chance meeting between planter John W. Graves of Newton County and industrialist and planter Mark A. Cooper of Cass County resulted in the first state agricultural fair being held in Stone Mountain in 1846. While the fair had humble beginnings, it grew in size. In 1847, it was held in a "ten pin" alley in front of the Stone Mountain Hotel. The last fair, held in 1849, was the largest, featuring a circus with a runaway elephant, exhibits, and manufacturing and agricultural awards.

The decade before the Civil War was a time of growth, with Stone Mountain village's four hotels and eight stores serving a population of about 300 in 1849. Most residents were native Georgians or South Carolinians, but a few hailed from the Northeast and England. Occupations were typical of a small town, and mercantilism, commerce, the building trades, and stonecutting were the major livelihoods. About 290 enslaved African Americans were also present working the fields, the quarries, the railroad, and in homes. Some of these individuals would help found Shermantown, an African American neighborhood established after the Civil War.

In addition to the hotel trade, Stone Mountain village was the home of the Stone Mountain Academy, which was incorporated and approved by the general assembly on December 31, 1838. Stone Mountain would maintain a strong academic presence throughout the 1800s, with both public and private schools. Churches were established early in the century. They included Baptist, Methodist, and Presbyterian congregations.

The antebellum village, part of DeKalb County, which had voted against secession, was physically untouched during the Civil War until the Battle of Atlanta. Visitors from Atlanta still made the trip out to the mountain even at the height of the war. Those on the home front were greatly affected by wartime conditions because of the absence of local men who were serving in the military. For example, the Wells family had five men—brothers, cousins, and in-laws—serving the Confederacy. Wives, mothers, children, and the elderly were called upon to harvest crops, work in and out of the home for pay, and, in general, do tasks that were once performed by men.

The Atlanta Campaign transformed the home front into a warzone, and Stone Mountain did not emerge unscathed. Stores, bales of cotton, and the granite depot were burned. Union forces pulled rails from the tracks and then heated and twisted them to make sure future use was impossible. A number of unknown Confederate soldiers who were mortally wounded during the many skirmishes are interred at the Stone Mountain City Cemetery. Others were treated in homes that were converted into field hospitals. One home had a cannonball preserved in its walls, a physical reminder of the war for decades. For many, however, the loss of family members was the paramount sacrifice made.

At the war's end, when the South began rebuilding, Stone Mountain granite was in demand. The Southern Granite Company, run by George Moerlin of Cincinnati, C.D. Horne, William Hoyt Venable, and Samuel H. Venable, was incorporated in the 1880s. The company and Stone Mountain were solely in the hands of the Venable brothers by 1887. This corporation ran the quarries that supplied Atlanta with much-needed building materials after the Civil War, as well as curbstones and other materials for innumerable other American cities. Skilled workers came to Stone Mountain from England, Scotland, Sweden, Norway, Wales, and Italy to ply their trade. Some made the village their home, joining the community, while others chose other paths. One source noted that Stone Mountain had "some rough edges back then."

The rough edges came with a job that was fraught with hard and dangerous labor. The first stabs at quarrying occurred between 1845 and 1850. In those first years, granite was quarried from partially disintegrated ledges. By the end of the century, granite was cut using mechanized techniques. The railroad was critical to the industry, allowing the mountain's granite to be shipped all over the country and beyond. The Dinky train connected the town and the quarries, bringing the men to the quarry sites and the granite to the depot for shipping. The Venables leased the mountain in 1911 to the Weiblen brothers of New Orleans, who operated quarries there as the Stone Mountain Granite Corporation until 1935.

The 1881–1882 *Georgia State Gazetteer and Business Directory* gave this fairly full description of the city: "Situated on Mountain Creek; has a population of 800 . . . It has two academies, several small schools, Baptist, Methodist and Presbyterian churches—white—and Baptist and Methodist churches—colored—two grist and flouring mills, one saw mill, cotton gin, and two cabinet shops, cotton gin, grist mill and drill operated by steam. One large distillery and quarry in operation here. Cotton, granite and whiskey are the principal shipments."

The business directory lists two African American churches, one Baptist and one Methodist. The records of the First Baptist Church note that African Americans were part of their congregation prior to the Civil War. Bethsaida Baptist Church was organized in 1868 and St. Paul African Methodist Episcopal Church was also a product of this period. Both are located within Shermantown, a neighborhood developed by freedmen and women on the southeastern edge of the city during segregation. The neighborhood featured a mix of small homes and a number of community buildings, including two lodge buildings, two churches, and a school.

Stone Mountain was the second-largest urban center in DeKalb County by 1890 and was coming into its own as a city. A battle was waged to move the county seat from Decatur to Stone

Mountain. It was won by popular vote but squelched by a vote in the legislative assembly. The village continued to prosper through World War I. Main Street was lined with stores, a bank, a post office, a pressing club, a feed warehouse, and an undertaker. City hall, the firehouse, and the jail were all located on Second Street, along with a blacksmith, a gristmill and woodworking shop, a car dealership, and the new Georgia Railway & Power Co. substation. The Stone Mountain Inn was constructed in 1905. A substantial granite public school served the white population. The University Boys School, established in 1900, was housed in an impressive brick building in the center of the city. A new streetcar line that linked Stone Mountain with Decatur in 1913 allowed town residents easy access to Decatur and Atlanta through a growing metropolitan mass transit system. The interurban line entered from the north, behind Ponce De Leon Avenue, and cut a loop through the downtown.

The quarry industry fueled the town's economy through the opening decades of the 1900s. Stone Mountain quarries produced 200,000 paving stones and 2,000 feet of curbing a day at the height of their operation. The Progressive era gave birth to the Stone Mountain Woman's Club, which became a force of change in Stone Mountain throughout the century, particularly in the 1930s and 1960s. The Masons were a fixture in the village since the 1840s, and other fraternal groups joined them almost a century later.

The economy started to decline in the 1930s. Cut stone became less popular as a building material as modern design and building techniques changed. Area residents struggled economically through the Depression. In 1938, Public Works Administration funds for the construction of a Rock Gym alleviated the plight of out-of-work stonecutters, both black and white. The community launched a major effort in the late 1930s to improve the appearance of the village coming out of the Depression.

The idea to carve a Confederate memorial into the side of Stone Mountain was generated in the early 1910s. The United Daughters of the Confederacy, led by Helen Plane, initiated the project by founding the Stone Mountain Memorial Association, hiring noted sculptor Gutzon Borglum, and securing a deed for the face of the mountain and 10 adjoining acres from the Venables in 1915. Disagreements over the deed to the land, financial woes exacerbated by the Great Depression, and World War II halted the project for decades.

While the establishment of the memorial was a boon to the area, other uses of Stone Mountain presented a darker side of life. After 1915, the top of the mountain was used by the resurrected Knights of the Ku Klux Klan for rallies. In 1958, the State of Georgia purchased Stone Mountain and the surrounding land in order to establish the park and complete the memorial. The purchase by the state ended the use of the mountain for Klan rallies. However, a field on the west side of the mountain became the focal point of Klan rallies, which included a parade through the village and Shermantown until the 1980s.

In modern times, the mountain, always the village's backyard, was now to be shared with the world. By the early 1960s, the village was beginning to show its age. Fearing decline, the Stone Mountain Woman's Club, along with other groups, pushed for the revitalization and rehabilitation of downtown Stone Mountain. Andre Steiner of Robert and Company Associates was asked to create a city plan, and, in January 1962, he presented progressive ideas to the community. While the whole of Steiner's design did not reach fruition, many of the aspects of his design were implemented and still survive today.

Stone Mountain came out of World War II and the park development era with new growth. Young veterans returned to the area, married, and raised families in new subdivisions blossoming on the outskirts of the city, choosing the small-town life they had enjoyed as children. Modern schools were built for both white and black children. Holiday parades, movies at the Mitchell Theater, and other town events punctuated life in this workingman's town. Main Street purveyed goods and services needed by village residents and the Mountain Pharmacy's backroom was the center of town life and gossip.

The city is now part of the Atlanta metropolitan area. New uses for historic buildings have been found, and 20th-century firsts include the election of the first female mayor, followed by the

first African American mayor. The historic village was listed in the National Register of Historic Places in 2000 as a "rare surviving example of a historic railroad town." It includes the homes of the town founders, the rail line, the central business district, residential neighborhoods, and community landmark buildings. Now, 175 years after its incorporation, a new municipal building has been constructed and Main Street's historic buildings have been enhanced with new sidewalks, landscaping, and public art that references the city's unique history.

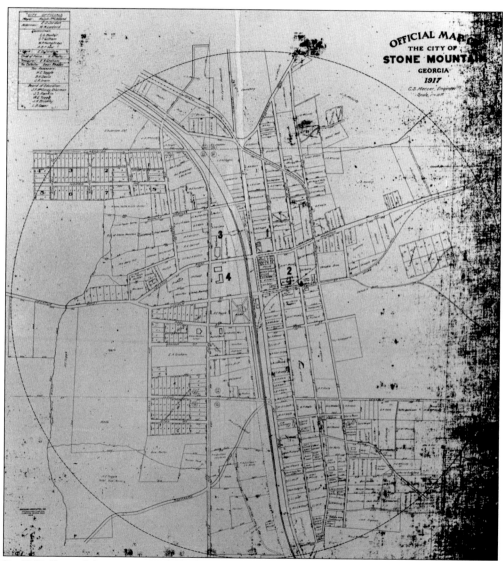

By 1917, Stone Mountain was fully developed, with a commercial block of granite and brick buildings across from the depot and residential streets featuring churches and schools stretching north and south from the town core. The depot was the heart of the village, but the new streetcar system had already made its imprint on the city's streets. Segregation had also changed the town, with the development of Shermantown, an African American neighborhood south of Venable Street and east of Main Street. (Courtesy of New South Associates.)

One

ROOTS

While Aaron Cloud's tower set the standard in 1839 for the mountain's future development as a tourist destination, a number of families and individuals helped shape Stone Mountain's development. Some descended from early settlers and others came during the boom period of the granite industry. Some of the early family names include Johnson, Lanier, McCurdy, Maddox, Jordan, Britt, Tuggle, Venable, Beauchamp, Mullennix, Rankin, Nash, Guess, Veal, Wells, and Nour. Many people from these families served as the town's first boosters and developers. Others served as the village's doctors, dentists, teachers, church organizers, elected officials, and police. The names of some of these men and women are carved along the trail to the mountain's summit, ensuring that future generations would be aware of their part in Stone Mountain's past. The city cemetery and its monuments also contain a significant record of the families who made their lives here.

In small-town fashion, marriages between the early families were numerous and often, helping to create a close-knit community settled around an urban core. Many families lived along the village peripheries in fairly rural settings. The influx of immigrants from England, Scotland, Sweden, Norway, Wales, and Italy during the height of the granite industry broadened that community, giving Stone Mountain an international flair in the late 1800s and early 1900s. Many of these men lived in town, boarding at local hotels and boardinghouses. The life stories of early African American families in Stone Mountain are more difficult to glean, and early photographs show only glimpses of individuals, usually at work.

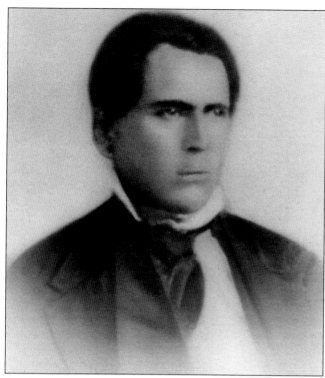

Andrew Johnson, a South Carolinian who came to Georgia about 1828, is arguably Stone Mountain's founder. The owner of the land on which the village was built, as well as the mountain itself, Johnson, a planter and entrepreneur, became a major player in the development of the village. He died in 1852, shortly after the village was established. Cited as the proprietor of the Stone Mountain Hotel in an 1845 advertisement, he likely developed two hotels, one in town and another at the base of the mountain. He is buried in the Johnson-Maddox-Goldsmith Cemetery on Memorial Drive. (Courtesy of the Colleti family.)

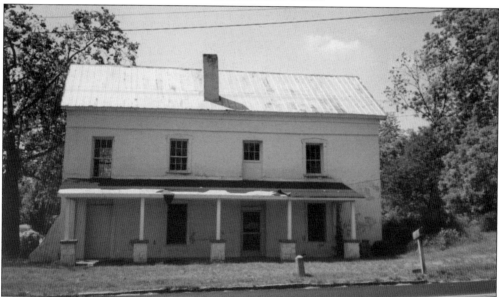

Owned by Andrew Johnson and considered to be the oldest building in Stone Mountain, this masonry building on Mimosa Drive predates the railroad, as a section of it was removed to allow for the railroad right-of-way. It was likely built by slave labor, and railroad workers were housed there when the railroad was constructed. It was later used as a hospital during the Civil War. Dr. John L. Hamilton, a physician, and his wife, Mary Marbut Hamilton, owned the building until 1928, after which the Ashe family used it as a residence and boardinghouse. (Courtesy of New South Associates.)

Aaron Cloud was Johnson's competition. His tower was the area's first engineered tourist attraction, rising to about 165 feet above the summit. As one writer states, "For 50 cents a visitor could lose his breath climbing the mountain, then pause for a second wind for the struggle up the 300 steps to the observatory." Telescopes allowed visitors to search the surrounding forest for visible landmarks, and a hall and shop under the tower offered other amusements. The un-anchored tower was blown down by wind, but not before opening up the mountain and its potential to Georgia's tourists for centuries to come. (Courtesy of the Stone Mountain Historical Society.)

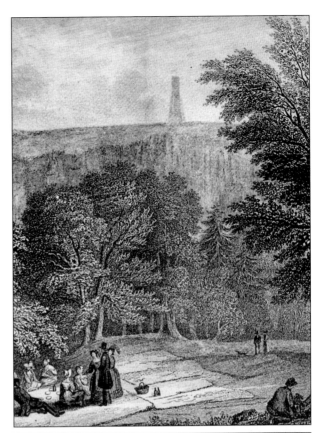

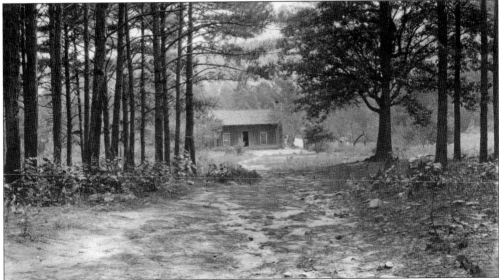

This simple house near the base of the mountain, in the vicinity of the Stone Mountain Woman's Club property, was home to the Mullennix family. The family history holds that ancestors constructed it using remnants from Cloud's Tower. Capt. Hoke Smith and a work crew demolished it during the construction of Stone Mountain Park, and the historic timbers were harvested for future interpretation. (Courtesy of the Mills family.)

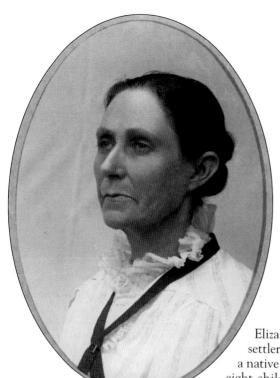

Elizabeth Rankin Lanier, a descendant of early settlers, married Arthur Washington Mullennix, a native of Baldwin County, about 1880. They had eight children, many of whom were lifelong Stone Mountain residents. (Both courtesy of the Mills family.)

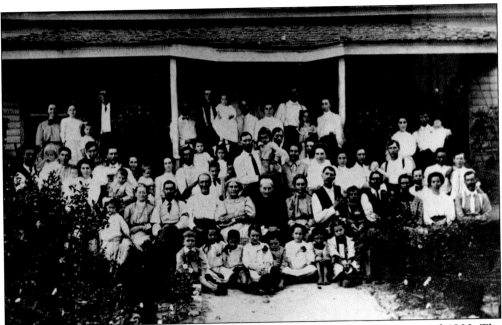

The Jordan family posed for the photograph above in front of their home around 1900. The family of 64 surrounds patriarch James Thomas Jordan and his wife, Lucinda Ellen Miller Jordan. The key below provides an identification of the family members present. (Both courtesy of the Jordan family.)

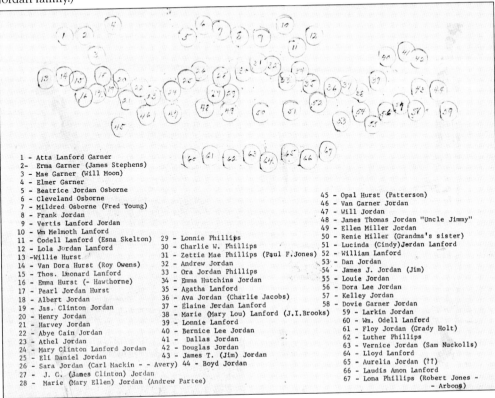

1 - Atta Lanford Garner
2 - Erma Garner (James Stephens)
3 - Mae Garner (Will Moon)
4 - Elmer Garner
5 - Beatrice Jordan Osborne
6 - Cleveland Osborne
7 - Mildred Osborne (Fred Young)
8 - Frank Jordan
9 - Vertis Lanford Jordan
10 - Wm Melmoth Lanford
11 - Codell Lanford (Esna Skelton)
12 - Lola Jordan Lanford
13 - Willie Hurst
14 - Van Dora Hurst (Roy Owens)
15 - Thos. Leonard Lanford
16 - Emma Hurst (- Hawthorne)
17 - Pearl Jordan Hurst
18 - Albert Jordan
19 - Jas. Clinton Jordan
20 - Henry Jordan
21 - Harvey Jordan
22 - Abye Cain Jordan
23 - Athel Jordan
24 - Mary Clinton Lanford Jordan
25 - Eli Daniel Jordan
26 - Sara Jordan (Carl Mackin - - Avery)
27 - J. C. (James Clinton) Jordan
28 - Marie (Mary Ellen) Jordan (Andrew Partee)

29 - Lonnie Phillips
30 - Charlie W. Phillips
31 - Zettie Mae Phillips (Paul F. Jones)
32 - Andrew Jordan
33 - Ora Jordan Phillips
34 - Emma Hutchins Jordan
35 - Agatha Lanford
36 - Ava Jordan (Charlie Jacobs)
37 - Elaine Jordan Lanford
38 - Marie (Mary Lou) Lanford (J.I. Brooks)
39 - Lonnie Lanford
40 - Bernice Lee Jordan
41 - Dallas Jordan
42 - Douglas Jordan
43 - James T. (Jim) Jordan
44 - Boyd Jordan

45 - Opal Hurst (Patterson)
46 - Van Garner Jordan
47 - Will Jordan
48 - James Thomas Jordan "Uncle Jimmy"
49 - Ellen Miller Jordan
50 - Renie Miller (Grandma's sister)
51 - Lucinda (Cindy) Jordan Lanford
52 - William Lanford
53 - Dan Jordan
54 - James J. Jordan (Jim)
55 - Louie Jordan
56 - Dora Lee Jordan
57 - Kelley Jordan
58 - Dovie Garner Jordan
59 - Larkin Jordan
60 - Wm. Odell Lanford
61 - Floy Jordan (Grady Holt)
62 - Luther Phillips
63 - Vernice Jordan (Sam Nuckolls)
64 - Lloyd Lanford
65 - Aurelia Jordan (??)
66 - Laudis Amon Lanford
67 - Lona Phillips (Robert Jones - - Arbon#)

15

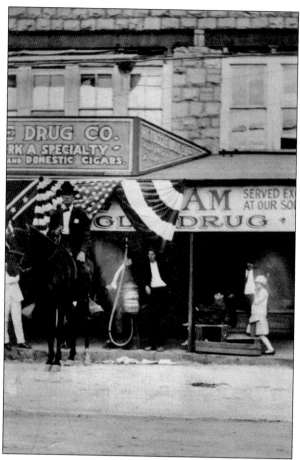

Sheriff John W. Beauchamp is seen here maintaining law and order on horseback on Main Street, likely during Fourth of July festivities. (Courtesy of the Stone Mountain Historical Society.)

The Mountain Street home of John W. and Sally Carter McCurdy is the backdrop for the family photograph below. From left to right are Dorothy Lillian McCurdy, John Steve McCurdy, Ida McCurdy Wells, Carl Thomas Wells, Sally McCurdy Haynie, John Dean Wells, John Wilson McCurdy, Sally Carter McCurdy, William S. McCurdy, Myrtice McCurdy, and Mr. Underwood, the minister of First Baptist Church. Two unidentified African American servants stand behind the family. (Courtesy of the Georgia Archives, Vanishing Georgia Collection, DEK-105-85.)

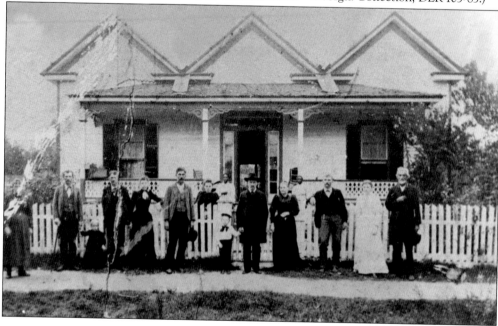

Elsberry Clinton Lanford, a Civil War veteran, and his wife, Carrie Mason Lanford, posed on their front porch with tulips for this springtime portrait around 1890. (Courtesy of the Jordan family.)

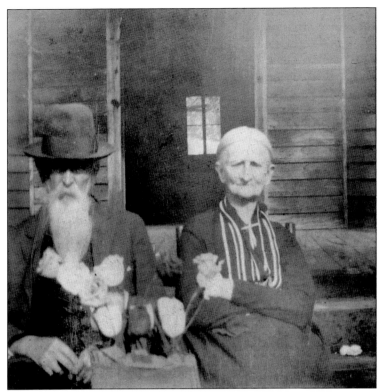

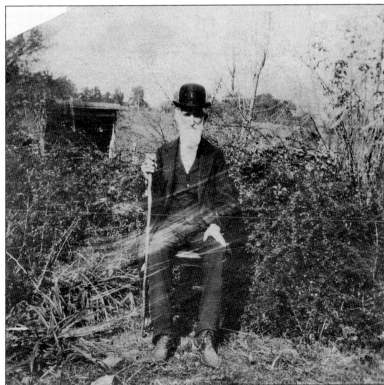

Early Stone Mountain resident G.W. Maddox, who served as a physician during the Civil War, sits for this outdoor portrait, suitably outfitted with a derby hat and a cane. (Courtesy of the Coletti family.)

Dr. James R. Wells was a longtime physician in Stone Mountain. Widowed early in his marriage, he, his daughter Janie, and his sister Mary lived in the white-columned family home on Ridge Avenue that was built in the 1870s by his father, George Riley Wells, a merchant and Civil War veteran. The Wells House is now the headquarters of the Stone Mountain Historical Society. (Courtesy of the Stone Mountain Historical Society.)

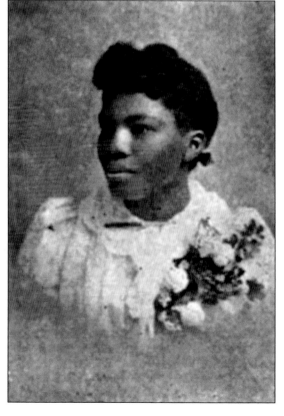

Victoria Maddox Simmons, a Stone Mountain native and childhood member of Bethsaida Baptist Church, attended Spelman Seminary in 1881, beginning her training as an educator. She would teach at Spelman after graduation and at Howe Institute in Memphis, Tennessee. The equalization school located in the Shermantown community in 1956 was named in her honor. (Courtesy of the Coletti family.)

Ransome Martin Thompson, the stately man in the center of this photograph, attended the Confederate Veterans convention at Stone Mountain in 1920. The Stone Mountain resident and Civil War veteran is buried in the Stone Mountain Cemetery, for which he donated part of the land. (Courtesy of Tug Tuggle.)

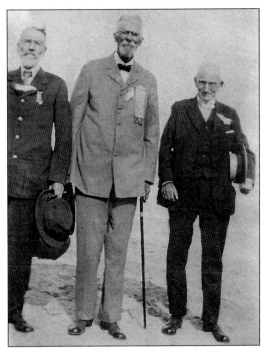

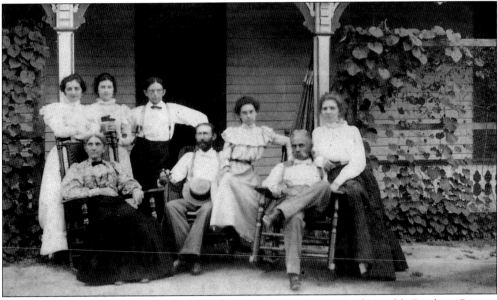

Samuel Hoyt Venable and his brother William Hoyt Venable organized Venable Brothers Granite Company in 1879. A year later, the brothers joined with the owners of Stone Mountain to form the Southern Granite Company. The Venables became the sole owners of Stone Mountain by 1887 and put the mountain at the forefront of Georgia's granite industry. They also donated the scarp of the mountain for the Confederate Memorial. Members of the Venable family posed for this 1898 photograph on the porch of Mont Rest, their summer home at the mountain. They are, from left to right, (sitting) Sarah Hoyt Venable, Dr. James N. Ellis, unidentified, William Hoyt Venable, and Elizabeth Venable Mason; (standing) Coribel Venable Kellogg, Bob Venable T. Roper, and Hamilton Wylie. (Courtesy of Tug Tuggle.)

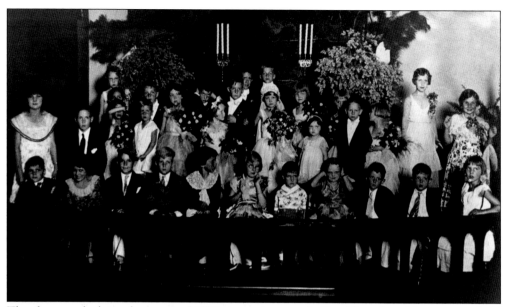

The photograph above, from around 1920, shows the cast of a Tom Thumb wedding pageant held at the Stone Mountain Methodist Church. It contains a number of future prominent community members. The program below contains a full list of the characters and actors, as well as period advertisements. While Peggy Tucker Peet, the bride, and James Spinks, the groom, kept their composure for the portrait, the children's expressions vary widely, adding interest to the photograph. (Both courtesy of Gary Peet.)

PROGRAM

Reading_____Rachel Sorrow
Solo_____Mrs. Vivian McDowell
Story_____Mrs. Carl Almand
Announcer_____Anne DeLoach

The Wedding Party

Bride_____Peggy Tucker
Groom_____James Spinks
Matron of Honor_____Bennie Lee Street
Maid of Honor_____Jean Thebaut
Best Man_____Lanford Jordan
Bridesmaids—Julia Ann McCurdy, Frances Cox, Mamie Ruth Pittard.
Groomsmen_____Baxter Googer, James Thomason, Delar Cox
Flower Girl_____Clara Jane DeLoach
Ring Bearer_____Bobby Dempsey
Father of Bride_____Hugh Jordan
Minister_____Sam Nuckolls, Jr.
Soloist_____Ann Thebaut
Pianist_____Ladimary Griffin

Families and Guests

Mother of Bride_____Emily Weiblen
Mother of Groom_____Hilda Pittard
Father of Groom_____Harold McClelland
Grandmother of Bride_____Mary Johnson
Grandfather of Bride_____Charles Tuggle
Twin Brothers of Bride_____James Tuggle, Bill Evans
Uncle of Bride_____Jackie Rhodes
Uncle of Groom_____Fred Mullinax
Aunt of Groom_____Betty Catherine Haynie
Friends of the Bride____Helen Thomason, Dorothy Dean Rhodes
Friends of the Family—Lucile McCurdy, Thomas McConnell, Clyde McCurdy.

The Nour family and store clerks, one of whom is dressed as Santa Claus, pose in front of The New Bee Hive, their store on Peters Street, advertising holiday goods. Immigrants from Lebanon, the family took over the historic Wayside Inn in the 1920s and then operated the Ideal Place, at the foot of the mountain. Though new to the village, the Nour family, especially Elias Nour (to the left of Santa Claus), would put their stamp on it. Elias's wife, Marie, is the second woman to the right. Their children are, from left to right, Elias Demetrius, Anthony Demetrius, and Katherine Alice. The doll Katherine is displaying remains in the possession of the family today. (Courtesy of the Coletti family.)

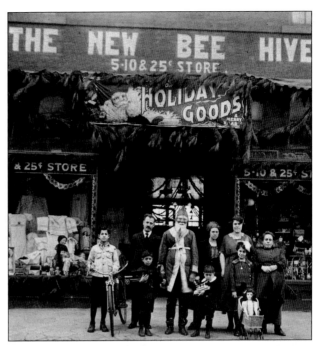

The McCurdy family was truly a Stone Mountain institution in terms of medicine and education. Over a century of teaching experience in Stone Mountain is represented in this photograph just between the three McCurdy sisters: Mary McCurdy, Myrtis McCurdy, and Sara McCurdy Evans. Dr. Willis McCurdy and his father, Dr. William T. McCurdy, were general practitioners for over 80 years in the village. Seen here from left to right are Mary McCurdy, Maimie McCurdy Britt, Myrtice McCurdy, and Sara McCurdy Evans; (standing) Dr. Willis McCurdy and John Steve McCurdy. (Courtesy of Jim McCurdy.)

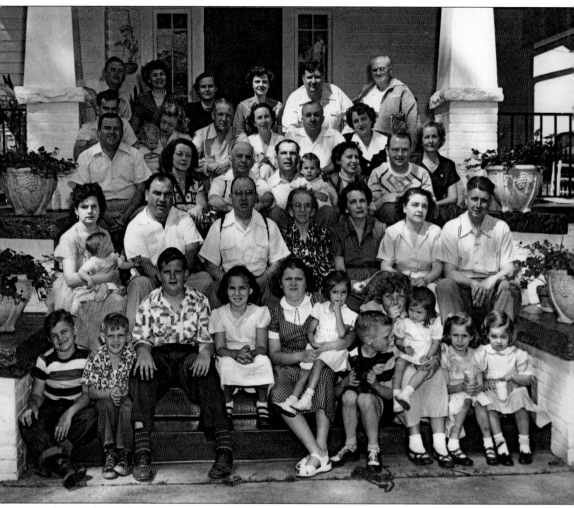

The Tuggle family was part of the town's social fabric, producing two generations of town dentists, Drs. Charles S. Tuggle Sr. and Jr., and others who played roles in the town's development. This 1949 reunion photograph, taken at the Britt-Tuggle House on Ponce de Leon Avenue, includes, from left to right, (first row) Fred Russell, Pierce Anderson, Ben B. Burgess, Mary Beth Tuggle, Joan Loftis, Janet Norris, H. Cherry Tuggle, Jo Anne Tuggle, Cheryle Vickery, Pamela Loftis, and Elizabeth Vickery; (second row) Mamie Tuggle Loftis, James Hunter Loftis Jr., James DuVall "Bebe" Tuggle, Charles Summey Tuggle Sr., Lena Brantley Hodo Tuggle, Martha Tuggle Burgess, Mary Tuggle Vickery, and Henry P. Vickery; (third row) Hilliard C. Tuggle Jr., Lucille Tuggle, John Pinckney Tuggle II, Howard Palmer Tuggle, Joy Tuggle, Grace Britt Tuggle, Charles S. Tuggle Jr., and Bertie Britt Tuggle; (fourth row) John Lee Stanley Jr., John Lee Stanley III, Martha Ann Burgess, Ben B. Burgess, Beth Almand Tuggle, Pete Norris, and Jo Helen Tuggle Norris; (fifth row) James Britt Tuggle, Lucille Anderson Tuggle, Frances Hewatt Tuggle, Mary Jo Vickery, James Hunter Loftis, and Will Loftis. (Courtesy of Tug Tuggle.)

Two

ALL ABOARD

In 1860, a visitor stepping off the train at the depot in Stone Mountain would see a village with a rural feel, with one- and two-story buildings scattered along its streets, their scale at odds with the immense mountain profile behind them. Churches and schools were in evidence at the time, and commerce was growing. Main Street was still developing. The new granite depot was completed in 1857.

Newspaper accounts in the *Macon Telegraph* in 1848 indicate that there was a "depot hotel" where visitors stayed through 1860. The Stone Mountain Hotel, a large brick building near the depot, however, was destroyed by fire in 1860, only partially rebuilt, and later sold at a sheriff's sale. Before the fire, horses and buggies were available at the hotel to bring visitors to the base of the mountain to the old trail, where they could ascend to the mountain's summit. The ruins of Cloud's Tower still interested the casual visitor. A restaurant on the trail offered sustenance to the hikers, many of whom would pause for photographs along the way.

By around 1900, photographs were more broadly taken, giving historians a better sense of what a visitor might see. A 1903 legal action between Stone Mountain and the Georgia Railroad produced a series of photographs, one taken at each railroad crossing in the corporate limits. The suit culminated with a reduced speed limit of six miles per hour for trains as they traversed the city, but it also created one of the best photographic records of the village as it entered the new century. The series of photographs, taken in May and July of 1903, takes readers on a tour of Stone Mountain by rail, starting at the southern corporate limits. The photographs from May, taken by Howe Photographs, feature views of the railroad corridor. These were supplemented by a second series taken in July by Julius L. Brown showing streetscapes and views adjoining the railroad.

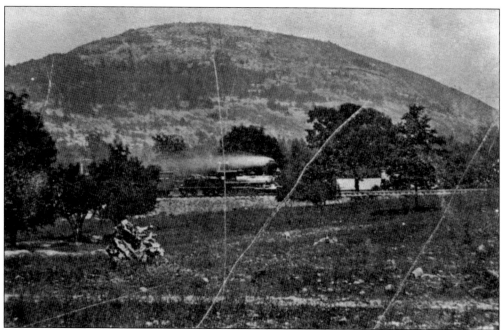

This 1896 view, taken from an open ridge that runs parallel to the railroad, shows a locomotive steaming through town. It captures fully the mountain's eastern profile, as well as the village's distinctive topography, buildings, and fence lines. This was the cover illustration for the sheet music of "Stone Mountain Echo Waltz," composed by Emma Virginia Summey of Stone Mountain. (Courtesy of the Stone Mountain Historical Society.)

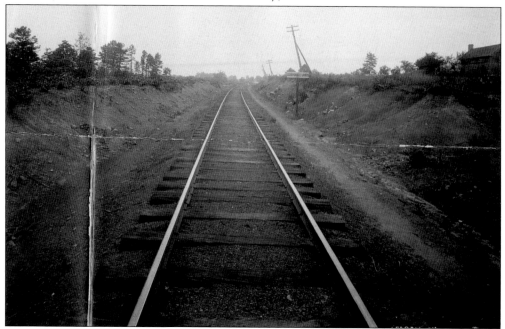

The train is coming into Stone Mountain from the south and a sign alerts passengers that they are entering the corporate limits. Telegraph poles set at a precarious angle parallel the railroad, and a single dwelling with two end chimneys faces the tracks. (Courtesy of the National Archives.)

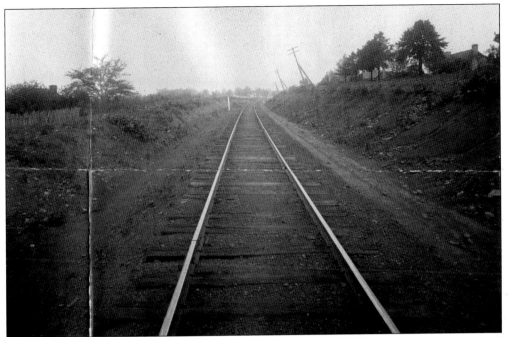

The village center lies in the distance and modest residences begin to appear on both sides of the railroad corridor. (Courtesy of the National Archives.)

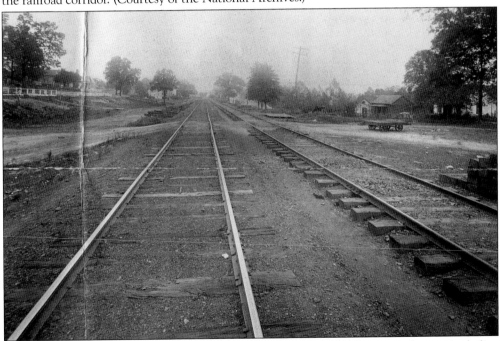

Sheppard Road skirts the west side of the tracks, and a number of 19th-century houses, including the Jordan and McClelland homes, are on the ridge overlooking the village, with fences demarcating property lines. In the distance, an old hotel lies by the depot. A second set of tracks appears at this South Main Street crossing on the approach to the depot, along with stacked lumber and a cart. On the right, cows nibble grass along South Main Street. (Courtesy of the National Archives.)

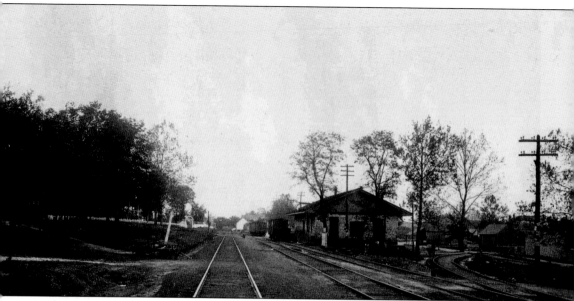

The depot is in the right background of this photograph, and the tracks used by the Dinkey, a small train run by the Stone Mountain Granite Corporation to take freight and workers to the mountain quarries, curve to the right. No large buildings are visible on Main Street. This crossing is denoted as the "Baptist Church crossing" on the back of the photograph. The park and gazebo by the depot are also seen, and the white fence of the University School for Boys is visible in the left background. (Courtesy of the National Archives.)

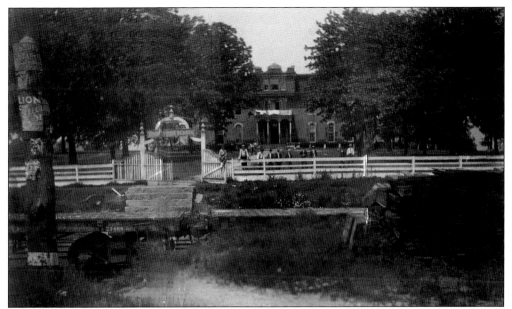

The University School For Boys was established about 1900. The campus was centered around this impressive two-story brick building, built in the Second Empire style on a large lot at the corner of Mountain and Main Streets. It was the village's most notable architectural landmark until 1975, when it was destroyed by fire. This view shows the campus, with its distinctive fencing and entry arches, students on the lawn, and bedclothes hung out for airing on the portico. (Courtesy of the National Archives.)

What is now the village's commercial strip was considerably less developed in 1903, as this photograph shows. Men and boys are seen here on Main Street busily conducting business among the spread-out, utilitarian frame buildings. Horses and carriages are plentiful on Mountain Street, and the imposing house of John McCurdy, on the corner of Mountain and Second Streets, is in the background. Only the two-story masonry building on Mountain Street, seen here next to the McCurdy house, still stands today. (Courtesy of the National Archives.)

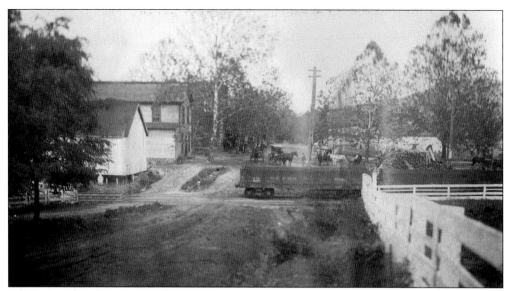

Georgia Railroad's wooden sidecars pass through the village at the busy railroad crossing at Mountain Street (formerly Tower Street). Horses, carriages, and pedestrians fill the streets, and commercial buildings anchor the intersection. The buildings on either side of Mountain Street may be attributable to George Riley Wells, a merchant and Stone Mountain native. (Courtesy of the National Archives.)

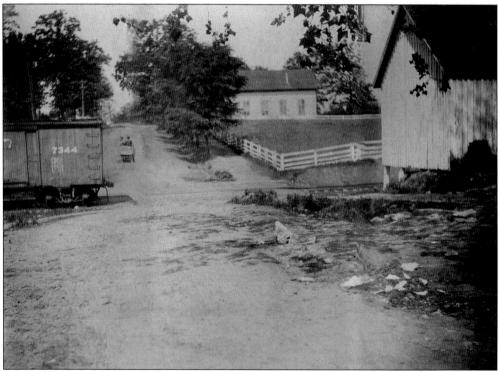

This view shows a carriage traveling west on Mountain Street, past the early Methodist church on the right. Trees are planted between the ample street and the walkway and a white fence surrounds the property. (Courtesy of the National Archives.)

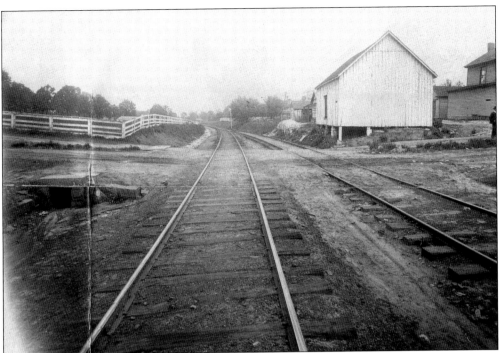

This view to the north shows the merging of the tracks. The frame building on the right is unidentified, but most of these sheds are attached to Main Street properties. A granite box culvert is in the left foreground. (Courtesy of the National Archives.)

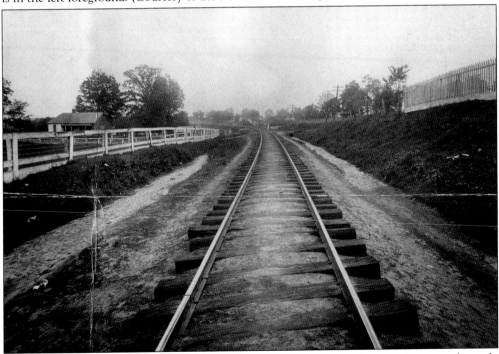

This crossing shows a return to a more rural landscape, as the corridor, now just a single track, curves westward towards Decatur. (Courtesy of the National Archives.)

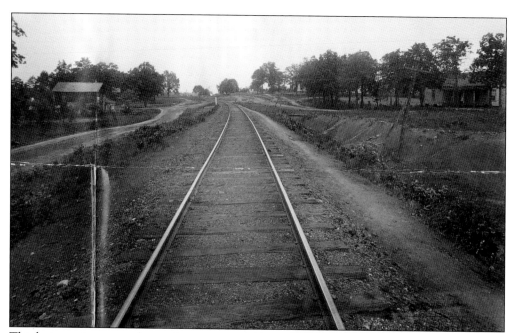

This last crossing was at the northern corporate limit of Stone Mountain. Ponce de Leon Avenue is on the right of the tracks and at least two dwellings are seen facing the track. Ridge Avenue is to the left of the rail corridor. (Courtesy of the National Archives.)

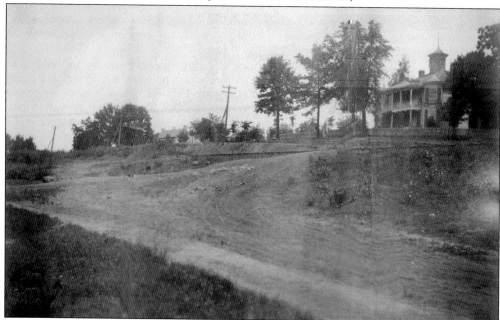

The Hamilton house (right), at the village's northern limit, was a sprawling Victorian jewel featuring a hip roof with a cupola, a two-story porch, and a turreted bay window. Dr. Hamilton, a physician during the Civil War, married Andrew Johnson's daughter, Mary. Local tradition says that a cannonball launched at the house during the Civil War was preserved in the building's cupola. The house was divided into apartments in the early 1900s and then eventually demolished. (Courtesy of the National Archives.)

Three

BOOMTOWN

In 1903, Main Street was a rural thoroughfare with most businesses clustered at the corner of East Mountain and Main Streets. Horses and carriages constituted most of the traffic. Whiskey, cotton, and granite were the city's main exports, while physicians, ministers, storekeepers, saloonkeepers, millers, an attorney, a teacher, a shoemaker, a watchmaker, a harness-maker, and a dentist all did business in Stone Mountain.

Within a decade, that sleepy ambience disappeared. Stone Mountain was the second-largest urban area in the county before World War I, and its business potential was touted in booster publications such as the 1914 Granite Highway Edition of the *DeKalb New Era*. While a designated Granite Highway never emerged, the progress forecast in the publication was spot-on. Stone Mountain had leading progressive citizens, strong business potential, educational centers, and a mountain that brought in industrial and tourism revenue.

By 1920, the downtown was fully built out with brick and granite buildings, a new school for white children was constructed, and the town's religious congregations had permanent structures. A public school for African American students was built with Rosenwald funding in the Shermantown neighborhood in the 1920s. Commerce was so strong that two banks were needed on Main Street. The original 1857 depot was expanded with a new building that housed the offices and passenger facilities, and a new inn offered Stone Mountain hospitality to tourists on Main Street. The University School for Boys also brought in scores of young men to the mountain town.

The Stone Mountain Granite Company was thriving, supplying building materials to local, state, and overseas markets, and the trolley had arrived. Momentum for a Confederate memorial on the mountain was building. Prosperity was also evident in new house construction, as the bungalow style made its appearance. The boom continued through World War I and into the early 1920s.

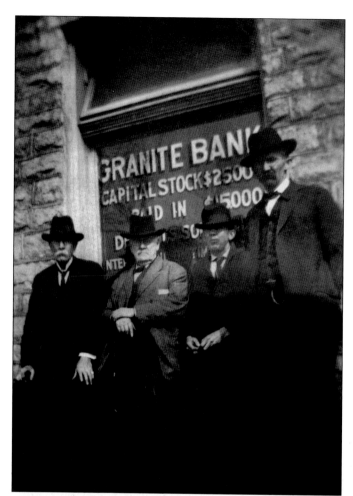

Advertisements touted that Granite Bank was "as solid as the Rock of Stone Mountain." Seen here in front of the bank around 1915 are, from left to right, John F. McCurdy, J. Steve McCurdy, Dr. W.T McCurdy, and an unidentified man. Granite Bank was organized in 1911 with J. Steve McCurdy as president, V.R. Williams as vice president, and J.R. Irvin as cashier. The list of the bank's directors was a who's who of Stone Mountain: W.A. Woodis, W.D. Maddox, C.J. Britt, W.E. Tuggle, John S. Candler, S.H. Venable, M.M. George, W.T. McCurdy, L.B. Greer, and D.F. Smith. (Courtesy of the Stone Mountain Historical Society.)

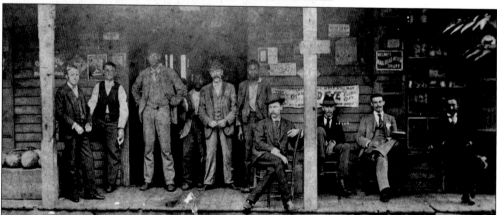

With its front wall covered with advertisements, the Wells Store, on Mountain Street, featured a shallow front porch where owners and patrons could gather. Seen here around 1890 are, from left to right, Pete Wells, Jim Woods, Niles Hadden, unidentified, Mark Wells, two unidentified, Dr. Raymond Wells, Mr. Hall, and unidentified. (Courtesy of the Georgia Archives, Vanishing Georgia Collection, DEK-177-85.)

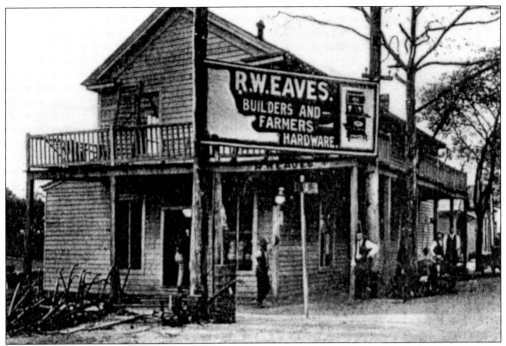

R.W. Eaves Builders and Farmers Hardware, at the corner of Main and Mountain Streets, was considered one of Stone Mountain's most substantial businesses in 1914. Eaves dealt in real estate, served on the county's board of education, and was the division deputy grand master of the Independent Order of Odd Fellows for the state. (Courtesy of Jim McCurdy.)

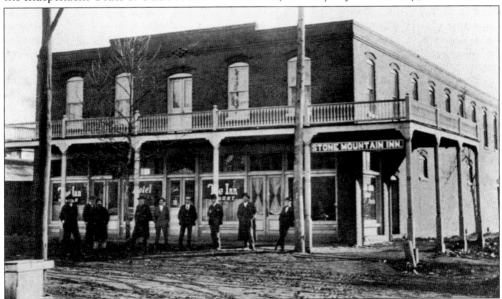

The Stone Mountain Inn was constructed across from the depot on the site of a former hotel in about 1905. Street Whittaker of Conyers is credited with its construction. The two-story brick hotel featured a two-story wraparound porch supported by turned posts so visitors could watch the depot action and look at the mountain. This photograph shows nine unidentified men posing in front of the building on an unimproved Main Street. (Courtesy of the Phillips family.)

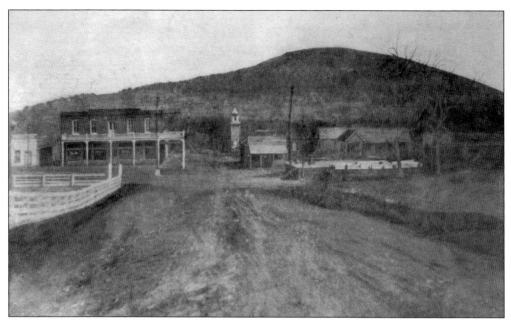

This is a long view showing the relationship between the new hotel, the depot, and the mountain. Main Street is considerably more developed and the Presbyterian church is in the background. (Courtesy of the Coletti family.)

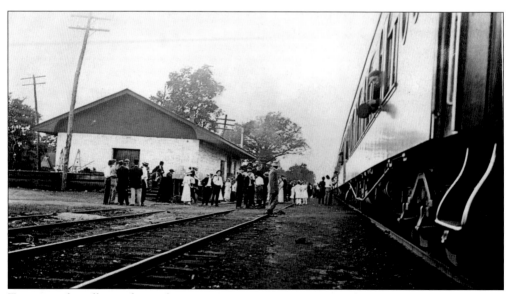

Townspeople spill over the tracks to meet an incoming train around 1910. Many talk to travelers in their seats while others watch from the depot platform. (Courtesy of the Mills family.)

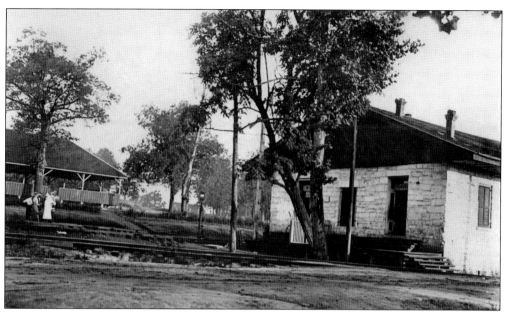

The 1857 granite depot was simply constructed, with a gable roof and two entries on the south end. The entrance closest to the tracks was signed for white use, and the second was a "colored" entrance. Behind the depot and opposite the tracks was a community gazebo where revelers danced during Second Saturday in May celebrations. (Courtesy of the Mills family.)

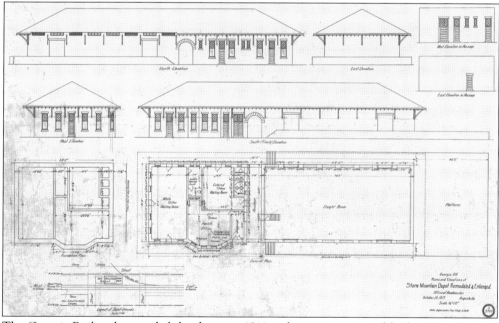

The Georgia Railroad expanded the depot in 1914 with a new granite ashlar building that was connected to the older building by an arched granite passageway. A shingled and tiled hip roof with support brackets also united the buildings. The old section was converted for use as a freight room while the new, "modern" section housed passenger services and the depot office. The plan of the new section reflected the times, with separate sections to accommodate white and black travelers during segregation. (Courtesy of the City of Stone Mountain.)

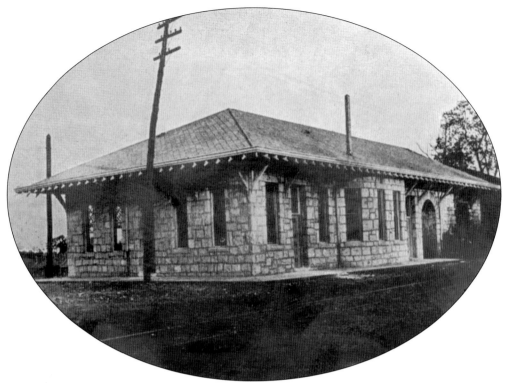

This view shows the new depot just after it was completed in 1914. (Courtesy of Jim McCurdy.)

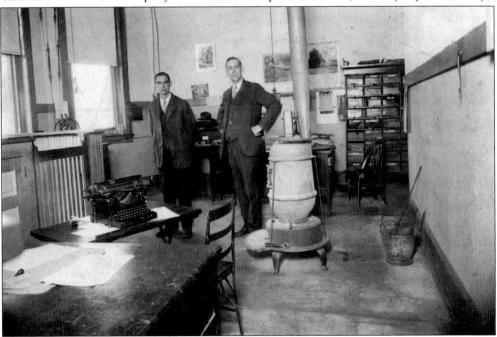

Archie Gresham Ogletree (left) worked as an agent in the Central of Georgia's stationmaster's office at the Stone Mountain depot, which was sparely furnished and heated with a potbelly stove in the late 1930s. (Courtesy of the Ogletree family.)

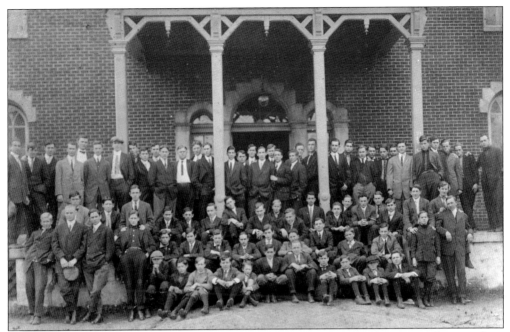

Students from the University School for Boys assemble on the portico for a group photograph in 1916. The student body included both local boys and boarders. Sandy Beaver, the school's president, supervised a teaching staff of five, including a physical education instructor, a matron, a cook, and a laborer. He left Stone Mountain in 1913 to become the renowned president of Riverside Military Academy in Gainesville, Georgia. (Courtesy of the Georgia Archives, Vanishing Georgia Collection, DEK-376-85.)

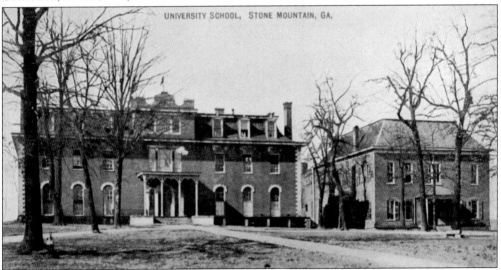

The school property included two adjacent buildings that were dissimilar in their architecture. The 1910 federal census indicates that the school and a boardinghouse operation were located on the university grounds. The boardinghouse was run by George and Ann Tanner in 1910, and its boarders included William Humphries, a drugstore proprietor; John Richie, a Scotsman and the superintendent of a granite quarry; Edwin Graham, a clerk at the railroad depot; and Eugenia Furlow. (Courtesy of the Georgia Archives, Vanishing Georgia Collection, DEK-408-85.)

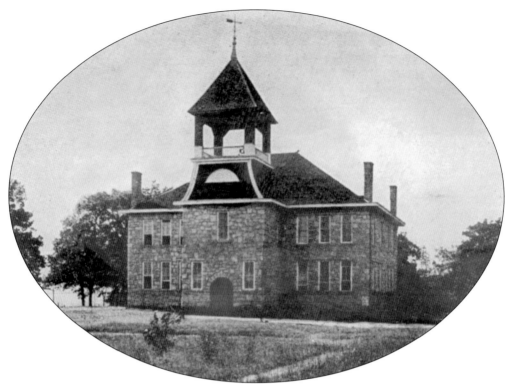

Stone Mountain Public School was constructed by 1914 at a cost of $10,000. Built of granite at the corner of Ridge Avenue and Manor Street, it was notable for its soaring bell tower. It was destroyed by fire in 1943. (Courtesy of Jim McCurdy.)

The Stone Mountain Colored Elementary School was constructed with funds from the Julius Rosenwald Fund, a Chicago-based philanthropic foundation aimed at improving the quality of public education for African Americans. The school, built in the vicinity of Leila Mason Park in Shermantown, likely followed a standardized plan, but was constructed on a granite foundation. (Courtesy of Narvie Jordan Harris.)

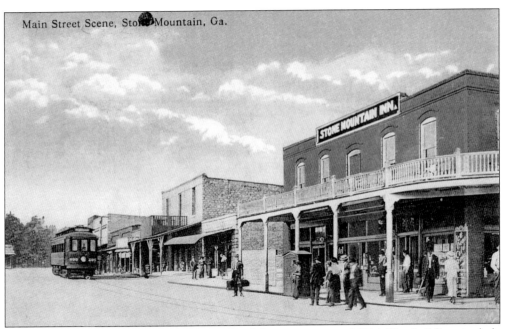

Main Street Scene, Stone Mountain, Ga.

This postcard shows a fully realized commercial downtown around 1914. The buildings include two banks, a Masonic lodge, retail stores, a feed store, and the inn, which is sporting new signage and a new look in preparation for a major newcomer: the trolley. The Stone Mountain Inn's porch, which once extended over the street, was altered to allow the new trolley to pass in 1913. (Courtesy of the Coletti family.)

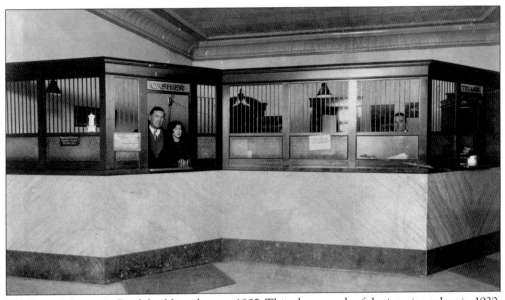

The Stone Mountain Bank building dates to 1905. This photograph of the interior, taken in 1920, shows a pared-down modern ambience. The man on the left has been tentatively identified as Asa Rhodes Dean. (Courtesy of the Georgia Archives, Vanishing Georgia Collection, DEK-372-85.)

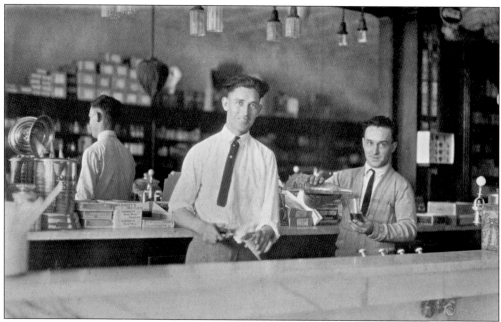

Around 1900, these two genial young men, Pat Ross (left) and John Harris, take orders at a well-equipped soda fountain in town, possibly the Irvin Drug Company on Main Street, which was within the McCurdy Granite Building prior to World War I. Dr. William T. McCurdy and J.R. Irvin, the cashier at the Granite Bank, were the proprietors. (Courtesy of the Stone Mountain Historical Society.)

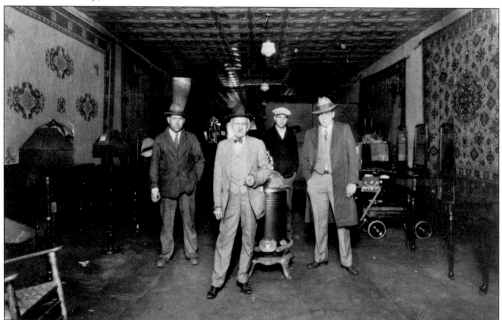

Steve Well's tin-roofed store at 953 Main Street sold furniture and rugs to the Stone Mountain community under the name of Stone Mountain Furniture Company. Seen here from left to right are William Gouge, Wes Smith, Pete Tuggle, and Steve Wells. (Courtesy of the Georgia Archives, Vanishing Georgia Collection, DEK-373-85.)

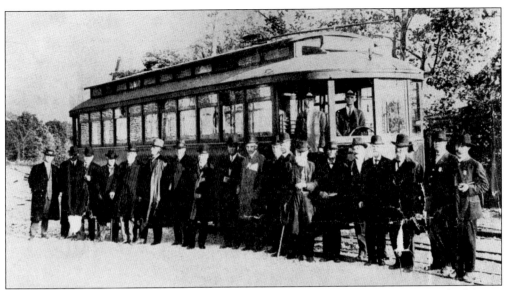

Tremendous change came in 1913 when a 9.15-mile interurban streetcar line reached Stone Mountain. The trolley line was constructed by the Georgia Railway & Power Company for about $400,000, and electric company officials and town dignitaries marked its arrival. Seen here from left to right are Howard Mathews and C.A. Smith of the power company; J.C. Hallman, the director of the power company; Murphey Candler Sr., a member of the railroad commission who later served on the public service commission; Frank E. Block; Jack J. Spalding; William Glenn; H.M. Atkinson of the power company; S.E. Simmons; Paul E. Reid; unidentified; Thomas Egleston; A.B. Sanders; A.B.F. Veal; J.T. McCurdy; Charles Rankin; O. Wellingham; Officer Carroll; and Chief of Police Mahoney. The conductors were not identified, but Pete Caldwell, a veteran conductor, was reported to be on the first streetcar. A streetcar was later named in his honor. (Courtesy of the Stone Mountain Historical Society.)

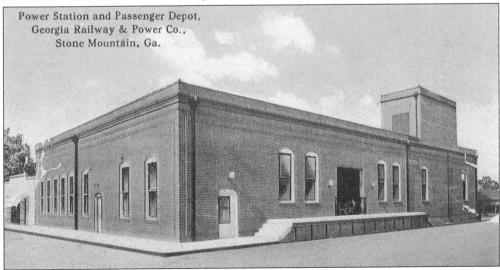

A large brick trolley barn was erected by the Georgia Railway & Power Company on Manor Street to accommodate the new interurban line. It contained passenger waiting rooms, a car shed large enough to handle 12 cars, a freight room, and an engine room. A blacksmith's shop was behind the building. (Courtesy of ART Station.)

A major streetcar stop was the corner of Main and Manor Streets, across from the depot and in close proximity to the city's neighborhoods. (Courtesy of the Coletti family.)

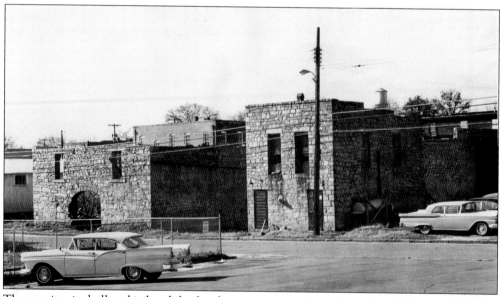

The granite city hall and jail and the fire department were located on Second Street in the early 1900s. City hall and the jail were housed in one building, and the fire department was directly adjacent to the south. A granite feed store, half of which is still standing, used to extend to Second Street below the fire department. This photograph, taken years later, shows the city hall and jail on the right, a vacant space where the fire department was once located, and the back of the feed store on the left with its arched entry on Second Street. (Courtesy of the Sanders family.)

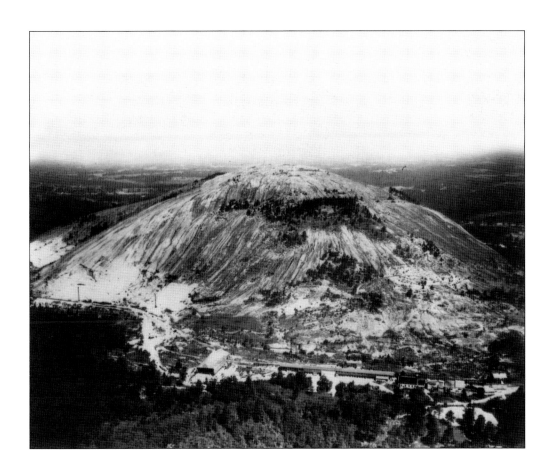

This 1937 aerial view of the western and southern sides of the mountain shows the extent of the large-scale quarry operations at Stone Mountain, first under the Venable brothers and then under the Weiblens. The Venable brothers were integral in putting Georgia on the map as a granite-producing state, and growth continued under the Weiblens. The detail below shows the office and industrial buildings of the quarry during the Weiblens' operations. (Courtesy of the Stone Mountain Memorial Association.)

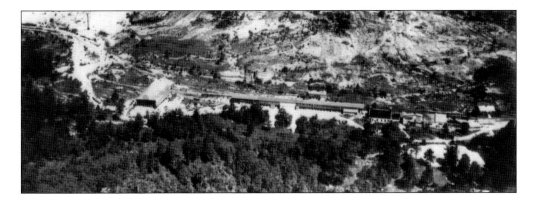

Stone Mountain's granite was used in paving projects throughout the South, as many cities began improving their streets and roads. This view shows laborers laying blocks from the mountain on Atlanta's Pryor Street. (Courtesy of Tug Tuggle.)

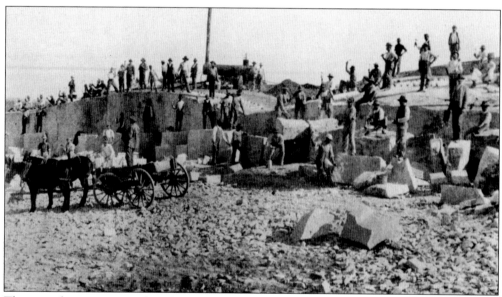

This view shows quarry workers, both white and black, cutting granite from an established ledge. By 1920, almost half of the workforce was African American, and the total number of workers at the Stone Mountain quarries made up about 13 percent of all the granite workers in the state. (Courtesy of the Stone Mountain Memorial Association.)

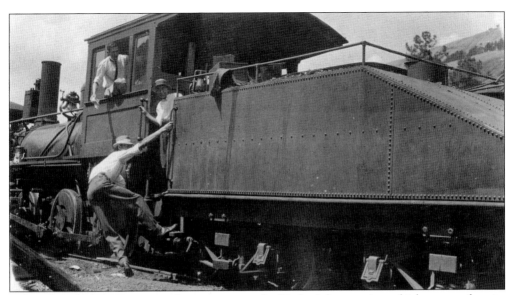

An unidentified man precariously steps up onto the Dinkey's locomotive, which traversed a spur from the village depot to the quarries. The mountain's slope is in the background. (Photograph by Jesse A. Wilson; courtesy of the Mills family.)

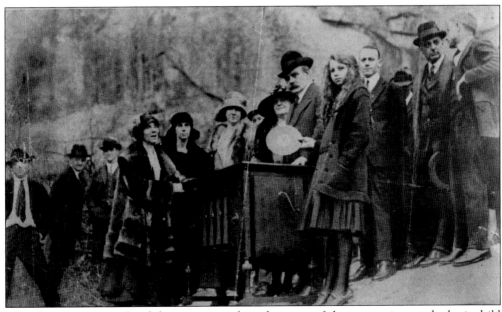

The idea of carving a Confederate memorial on the scarp of the mountain was the brainchild of Helen Plane, a charter member of the United Daughters of the Confederacy (UDC). Her idea received traction when the Venable family, who owned the mountain, gave the UDC a 12-year lease in 1916 to complete the immense project. Gutzon Borglum was first chosen as the sculptor, but there would be two others before Plane's idea was fully realized. This view shows a test of the sound quality of the "outdoor stage" created by the steep side of the mountain. A young Leila Mason, standing next to Borglum, casually holds the test record amidst the large group of dignitaries. (Courtesy of Gary Peet.)

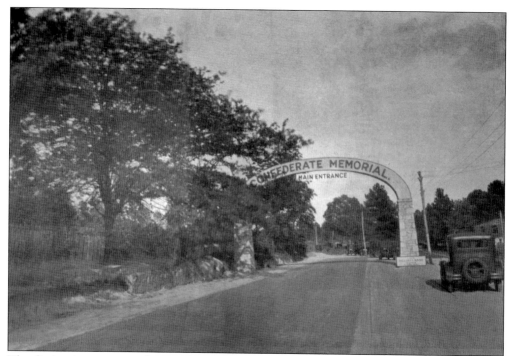

The distinctive granite arch over the main entrance of the Confederate Memorial is seen here in September 1927, along with an improved Route 10. (Courtesy of University of Georgia Map & Government Information Library.)

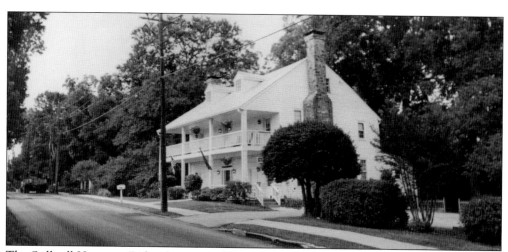

The Stillwell House, at Ridge Avenue and East Mountain Street, is a two-story frame building that was an early inn, a Confederate hospital, and the home of Rev. Jacob Stillwell and his large family in the 1800s. (Courtesy of New South Associates.)

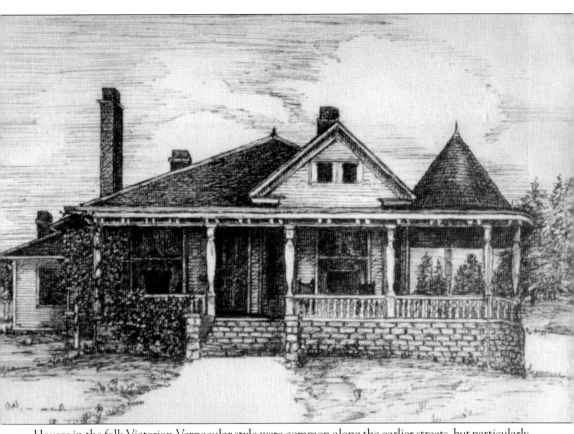

Houses in the folk Victorian Vernacular style were common along the earlier streets, but particularly along the railroad. The McClelland House, seen here, was constructed in the 1880s and later purchased by the Jordan family. (Courtesy of the Jordan family.)

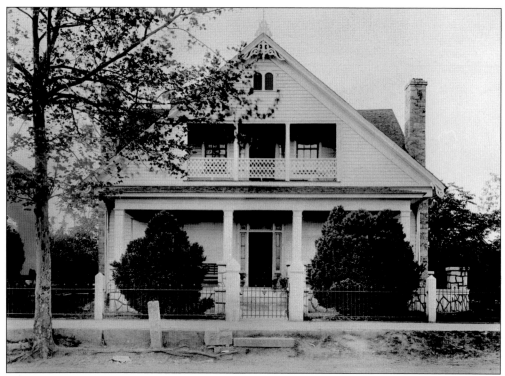

John Franklin McCurdy constructed this notable home on the corner of East Mountain and Second Streets that reflected late Victorian influences and the availability of granite. (Courtesy of the Georgia Archives, Vanishing Georgia Collection, DEK-406-85.)

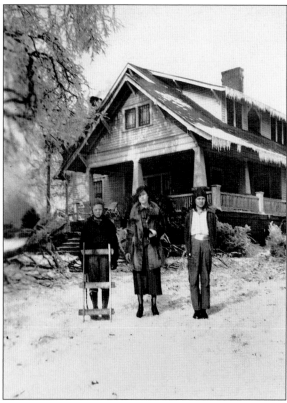

The bungalow style arrived in the first decades of the 1900s. The Britt-Tuggle House, constructed by James Willis Britt in 1910 on Ponce de Leon Avenue, was the home of his daughter Bertie and son-in-law Dr. Charles Summey Tuggle Sr. Here, from left to right, James Britt Tuggle, Bertie Britt Tuggle, and Charles Summey Tuggle Jr. appear ready for some icy weather around 1933. (Courtesy of Tug Tuggle.)

Four

PLACES OF WORSHIP

By the Civil War, at least three church congregations had been organized in Stone Mountain, and two more followed soon after. The first place of worship for all denominations in Stone Mountain was a building located within the fairgrounds, where the state fairs were held in Stone Mountain in the late 1840s. It was likely in the vicinity of Third Street and Manor Drive, which was once known as Church Street. The Presbyterian church, the only congregation no longer in the area, appears most in historical photographs, due to its location with the mountain as its backdrop. By 1900, both the Baptist and Methodist congregations had moved across the tracks to Ridge Avenue, where new neighborhoods were developing.

The First Baptist Church, first known as the Rock Mountain Baptist Church, was formed in 1839. It is the oldest congregation in the city. Church records indicate that the congregation included both white and black members at least through 1867. The congregation had three previous church buildings before its current one, two of which were destroyed by fire.

The Stone Mountain Methodist Church was organized about 1854. In the early 1900s, a new church built of granite from locally quarried stone replaced the simple frame church at East Mountain Street and Ridge Avenue. The Stone Mountain Presbyterian Church conducted services at the corner of Third and Manor Streets in a simple frame building that was torn down in the 1930s. The congregation was eventually subsumed by other Methodist congregations in the Stone Mountain vicinity.

Two African American churches were established in Shermantown after the Civil War: Bethsaida Baptist Church and St. Paul African Methodist Episcopal (AME) Church. Stone Mountain granite was used by Bethsaida Baptist in the construction of their new church, built on Fourth Street in 1920. The church had organized in 1868–1869 under Rev. H.H. Brown and held services in a frame structure prior to 1920. St. Paul AME Church was organized after the Civil War and is housed in a brick building on Third Street.

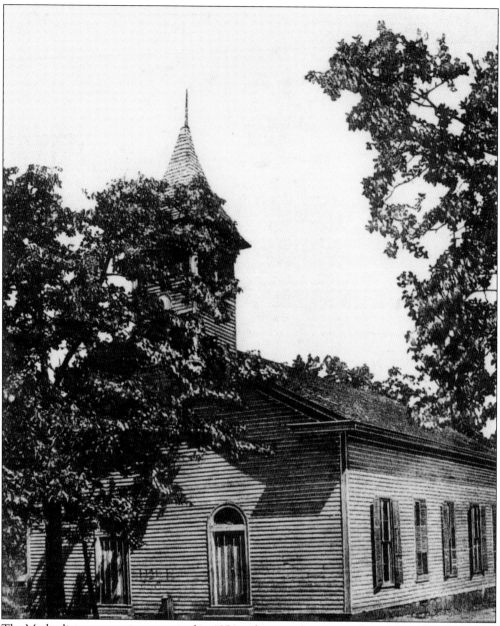

The Methodist congregation organized in 1854 with seven charter members: Mr. and Mrs. Andrew Camp, Mr. and Mrs. Maxie Waits, Mrs. J.G. Rankin, Mrs. Oliver Winningham, and Mrs. Ira Camp. The growing congregation alternated with other faiths at the general church building until 1870, when their first wooden church was built at the corner of Mountain Street and Ridge Avenue. (Courtesy of the Jordan family.)

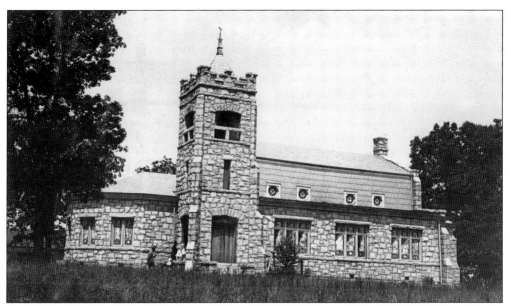

The cornerstone was laid for the current church in 1909, and construction of the Stone Mountain granite church formally ended in 1926, as it was completed gradually. The church's historical records state, "So anxious were the members to get into the new granite edifice, that small inconveniences—like bare rock walls and no windows—did not dampen their spirits." (Courtesy of the Mills family.)

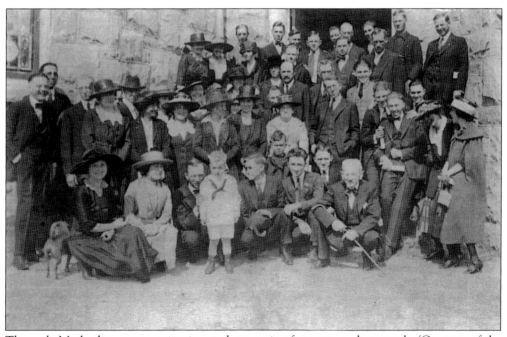

The early Methodist congregation is seen here posing for a group photograph. (Courtesy of the Jordan family.)

The First Baptist Church of Stone Mountain is the city's oldest, tracing its origins to 1839. When it was reconstituted in 1847, its membership of 21 individuals was under the spiritual guidance of Rev. David Cook. Church records show that the congregation included both white and black members. Its first building was constructed in the vicinity of Third Street between 1848 and 1851. That building was sold in 1873 when the congregation moved across the tracks to a lot on Mimosa Drive and Ridge Avenue, where it remains today. Fires in 1934 and 1937 destroyed two earlier church buildings, and the sanctuary and some furnishings in the new building (seen here) were destroyed by fire in 1964. (Courtesy of the Hamby family.)

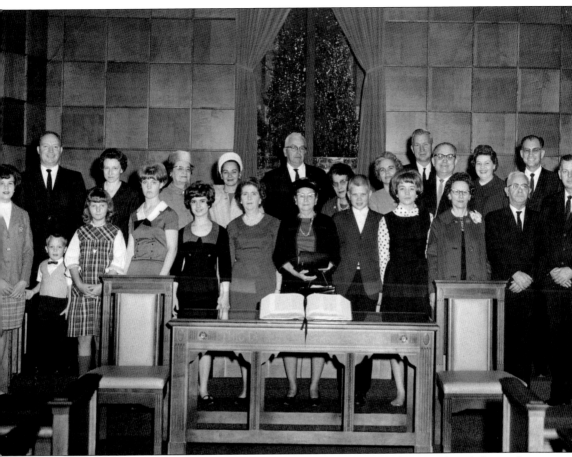

Baptist congregants are seen here in front of the altar around 1960. They are, from left to right, (first row) Susan Hicks, Tim Alexander, Brenda Drozak, Beth Rawlins, Kathy Beazley, Martha Beazley, unidentified, Chris Brand, Lynn Brand, Montine Waters, J.B. Waters, and Reuben Mobley; (second row) Gerald Alexander, Inez Alexander, Lesline Dolvin, Pat Drozak, William Allen, Frances Allen, Joe Brand, Mary Brand, Melvin McCullers, Nell Pedigo, and Leonard Pedigo. (Courtesy of the Hamby family.)

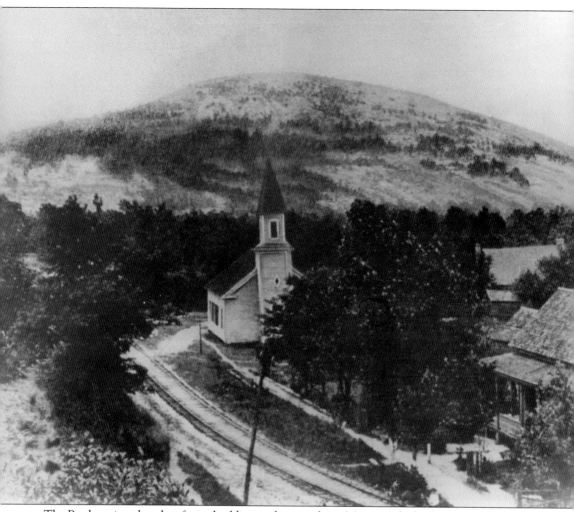

The Presbyterian church, a frame building with a steeple on Manor and Third Streets, was possibly built on the former site of the First Baptist Church. A postcard showing its modest steeple set against the profile of the mountain became an iconic 19th-century image of the village. The congregation dissolved in the early 1900s after the building was demolished. (Courtesy of the Stone Mountain Historical Society.)

Bethsaida Baptist Church was organized in 1868 under the direction of Rev. R.M. Burson, and the congregation's granite church was built on Third Street during the pastorate of Rev. F.M. Simmons. It is likely that some of the members once worshipped at the First Baptist Church before the Civil War. The Venable brothers donated the granite for the church, and the African American congregation, many members of which worked in the quarries, hauled the granite to the site and constructed their church. This photograph shows the church after completion with an unidentified child and a dog in the foreground. Towers have since been added to the front of the church. (Courtesy of the Stone Mountain Historical Society.)

The Bennefield brothers, seen here, were Shermantown quarry workers who helped build Bethsaida Baptist Church. (Courtesy of the Stone Mountain Historical Society.)

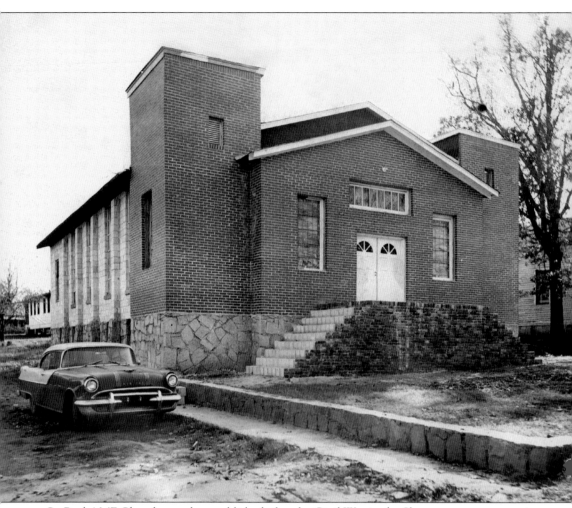

St. Paul AME Church was also established after the Civil War in the Shermantown community. The current brick building, with a granite foundation and corner towers, is on Third Street. It was constructed in 1959 under the pastorate of Rev. Lonnie Young and prelate bishop William R. Wilkes. (Courtesy of the Stone Mountain Historical Society.)

Five

THE BACKYARD

The village threw in its lot with the mountain in 1839, and its sense of place has been joined with the mountain ever since. The mountain was the town's backyard and a part of everyday life for Stone Mountain folks—a part of their identity. It provided beauty, serenity, danger, commerce, challenges, controversy, and fun. In 1896, village resident Emma Virginia Summey wrote the rousing "Stone Mountain Echo Waltz" in its honor, and George Riley Wells referred to himself as a "mountain man" in his letters home during the Civil War.

Postcards and visitors typically captured the grandeur of the steep side of the mountain or the stark beauty of the summit. Local photographs, however, were more likely to use low-lying boulders or ledges as backdrops for family photographs or capture the feats of area residents as they walked or drove its slopes in good weather and bad. Many who grew up in the village had memorized its geography and vegetation, as well as its legends and folktales, by the time they were teenagers.

If Aaron Cloud put Stone Mountain on the map as a tourist destination in the 1840s, the Nour family kept the visiting public interested in the 1900s with their souvenir shop and restaurant at its base. Elias Nour, known as the "man of the mountain," kept mountain visitors safe. The establishment of Stone Mountain Park in 1962 put a fence between the village and the mountain for the first time, bringing an era of change for residents used to having the mountain in their backyard.

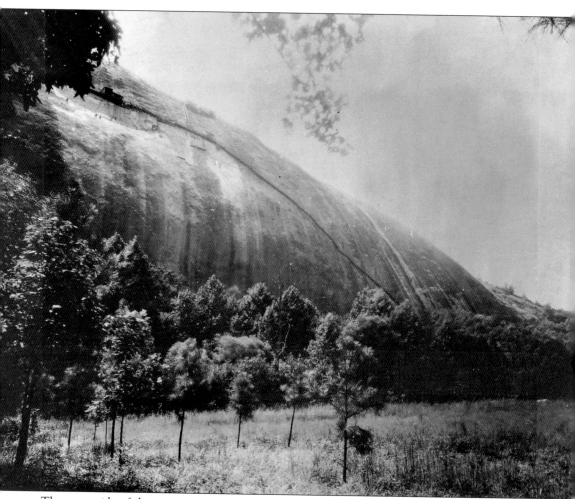

The steep side of the mountain was the subject of many iconic photographs due to its beauty and the growing interest in a Confederate memorial carving. (Photograph by John Fred Maddox; courtesy of the Coletti family.)

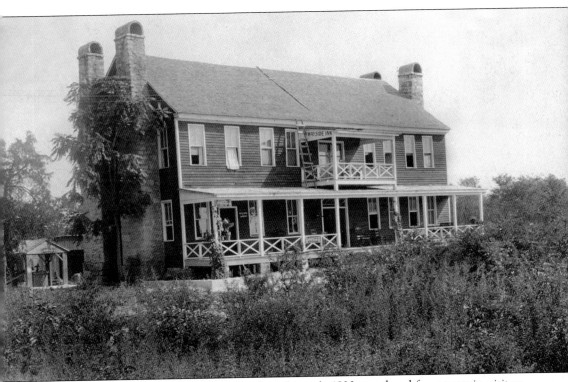

The Wayside Inn was a local landmark built in the early 1830s as a hotel for mountain visitors, possibly by Andrew Johnson or his descendants. The two-story building, with its ample porch and double end chimneys, remained in operation though the 1920s, roughly in the location of what is now the parking lot for Stone Mountain Park's Confederate Hall. A well house and a support structure sit behind the historic inn. It was purchased by the Nours and destroyed by a fire in 1925 while the family was overseas. (Photograph by Jesse A. Wilson; courtesy of the Mills family.)

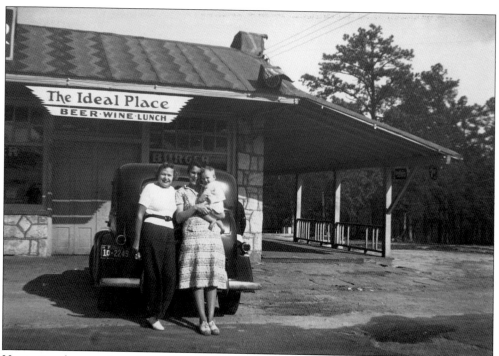

Harvesting the stone from the ruins of the Wayside Inn's four chimneys, the Nours built a restaurant called the Ideal Place, as well as a dance hall, a souvenir shop, a bowling alley, and a gas station at the base of the trail to the mountain's summit. Confederate Hall, in Stone Mountain Park, was later built behind the restaurant site. Katherine Coletti is pictured here on the right holding her son George. (Courtesy of the Coletti family.)

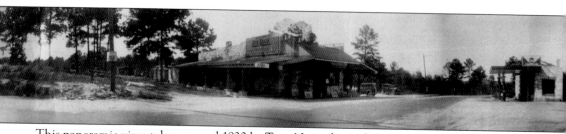

This panoramic view, taken around 1930 by Tony Nour, shows the activity at the

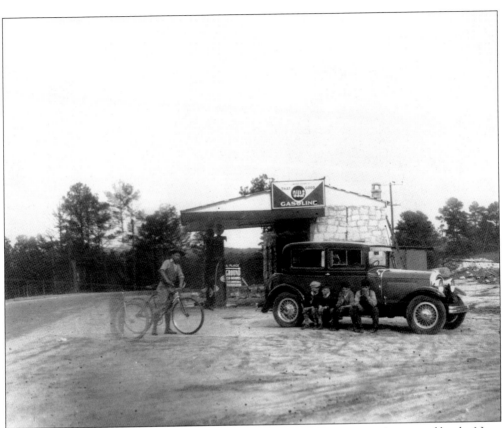

Children on bikes and on foot gather at the small, two-pump stone gas station owned by the Nour family that sold "That Good Gulf Gasoline." (Courtesy of the Coletti family.)

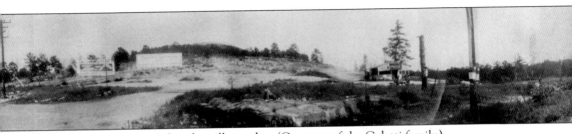

base of the mountain trail at the village edge. (Courtesy of the Coletti family.)

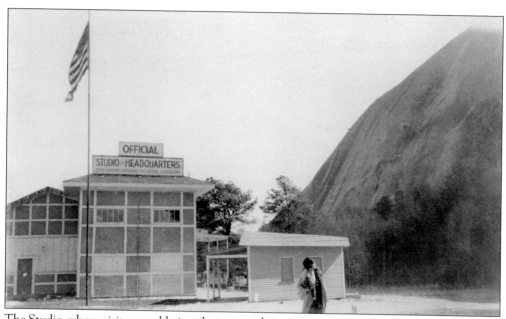

The Studio, where visitors could view the proposed carving models for the memorial on the other side of the mountain, was also part of the village's geography and its tourist trade. (Courtesy of the Stone Mountain Memorial Association.)

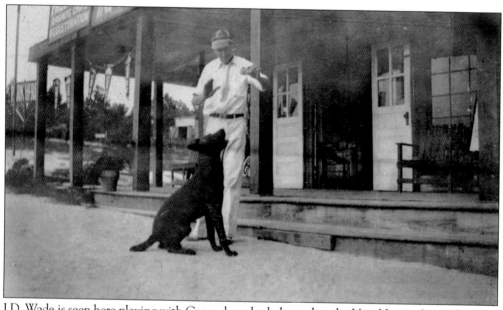

J.D. Wade is seen here playing with Gas, a dog who belonged to the Venables, in front of Studio. (Courtesy of the Wade family.)

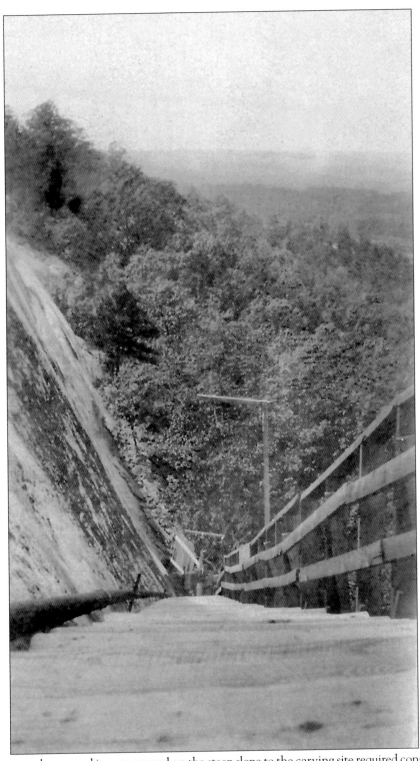

The staircase that wound its way upward on the steep slope to the carving site required considerable concentration to ascend. (Courtesy of the Wade family.)

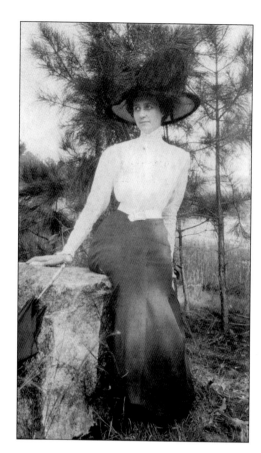

Real estate developer Jesse A. Wilson created these portraits of his wife, Pauline Mullennix Wilson, and his father-in-law, Arthur Washington Mullennix, posed on a granite ledge around 1915. The Wilsons resided on East Mountain Street. (Both courtesy of the Mills family.)

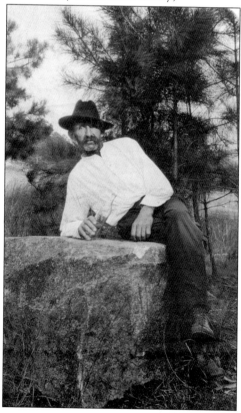

This informal 1895 image shows three African American children on the mountain with the village in the background. Two children are in a tree and another is relaxing on the rock. (Courtesy of the Coletti family.)

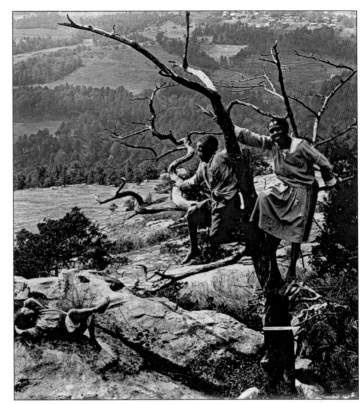

Below, Eola and Louise Nour strike a pose with an ancient cedar on the mountain slope. (Courtesy of the Coletti family.)

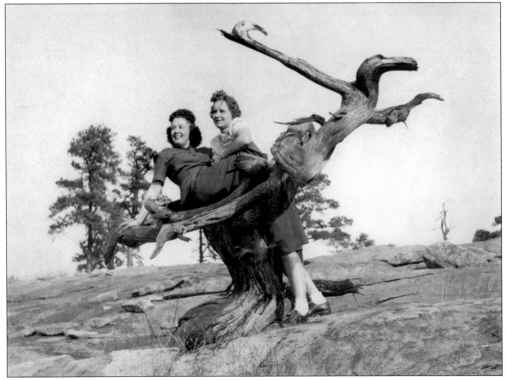

Betty Haynie Jordan and Lady Mary Griffin McConnell cut up for the camera in 1939. (Courtesy of the Jordan family.)

Stone Mountain's precarious ledges and gradual slope attracted these explorers, who sought more adventurous photographic opportunities. Tony Nour is shown below above the carving. (Both courtesy of the Colleti family.)

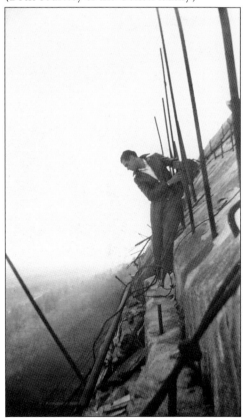

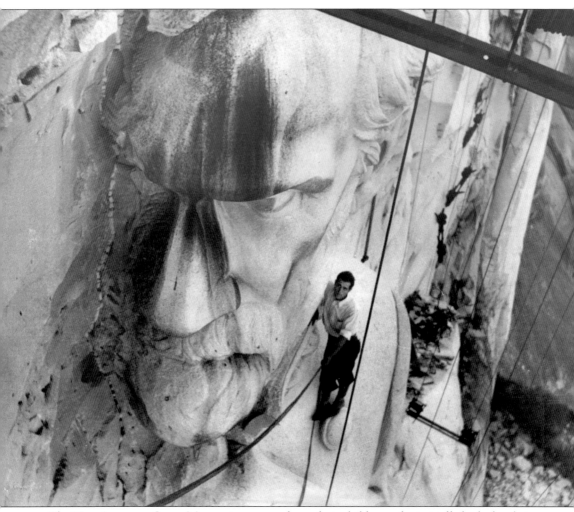

The Nours' move to Stone Mountain was rough on their children, who initially had a hard time fitting in. Elias Nour spent his time on the mountain, exploring it, learning its geography, and honing his considerable climbing skills. Both a daredevil and a savior, he rescued 36 people and six animals that had slipped off the mountain summit and were clinging to shallow ledges. His knowledge of the mountain and his prowess earned him the name "man of the mountain." He is seen here climbing on the unfinished memorial carving, preparing to swing to another area of the carving. (Courtesy of the Coletti family.)

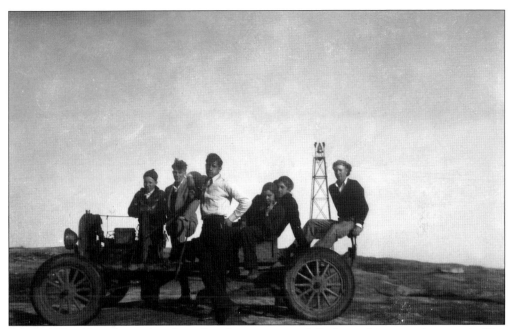

A proud Elias Nour (center) and an all-male crew successfully drove this car to the summit. The early communication tower is in the background. (Courtesy of the Coletti family.)

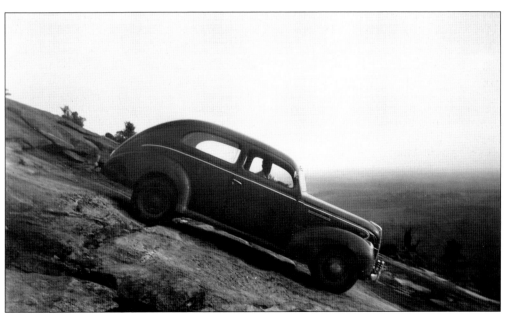

Driving down the mountain took considerable skill and caution, as seen here. (Courtesy of the Coletti family.)

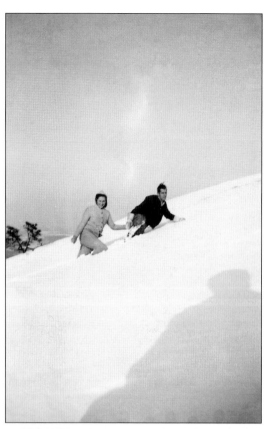

Trekking up the mountain in deep snow was a serious undertaking that required skill and caution. (Courtesy of the Coletti family.)

A confident Hugh Jordan is seen below climbing the carving site's scaffolding in 1939. An emerging visitors' complex for the park lies below. (Courtesy of the Jordan family.)

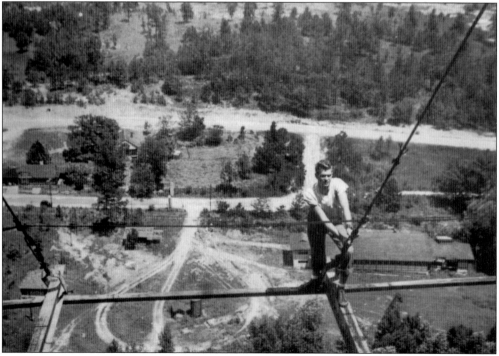

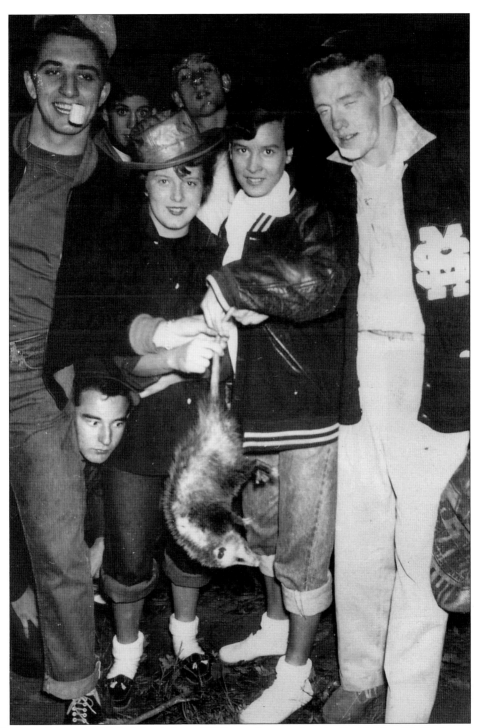

The Stone Mountain High School class of 1955 went "possum hunting" with Mary McCurdy as their chaperone. The class trip ended with a cookout, and the bewildered possum went home unscathed. From left to right are Howell Hamby, John Attaway, Vauneana Atkins Wade, Winford Harris, Beverly Thomas, and Bobby McCurdy. Tony Miller is on the ground. (Courtesy of JoAnn Florence.)

Alice McCurdy and an unidentified photographer accompanied Sir Edmund Hilary (right), the international explorer and mountain climber, to the mountain summit, proudly showing him the city's landmark. McCurdy reported that Hilary was not impressed. (Courtesy of Jim McCurdy.)

Six

THE DEPRESSION AND WORLD WAR II

The years between 1925 and 1940 were rough going for all of Stone Mountain. The Weiblens steered the Stone Mountain Granite Corporation through World War I, the 1929 stock market crash, and much of the Great Depression, but they were unable to weather a sharp increase in freight rates in the 1930s. Their lease with the Venables ended in 1935 after a long dispute, after which the Works Progress Administration (WPA) operated quarries at the mountain for a short time. Area stonecutters were out of work and other industries were also feeling the economic downturn.

In 1938, relief came to Stone Mountain and many other communities in the granite belt when funding was provided to build a series of gymnasiums and auditoriums under Pres. Franklin D. Roosevelt's New Deal. A large rock gym and auditorium with a barrel roof was constructed adjacent to the public school by out-of-work area residents in the village. The building became a community landmark, particularly after the adjacent school was destroyed by fire.

The town shook off its woes by the late 1930s, only to find that its sons were needed on the front lines. Many young Stone Mountain men, black and white, served in World War II. Stone Mountain lost only one soldier in the war; his death had a great impact on the close-knit community and was captured in a solemn series of photographs that appear in many residents' scrapbooks.

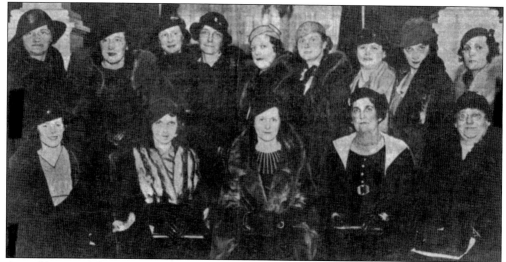

Arguably one of the most important dates in Stone Mountain's history was December 5, 1929, when the Stone Mountain Woman's Club was founded. Its motto, "Service to Community, Home and Fellow Man," has been followed to the letter through the decades. The organization's first president, Grace Harris, is seen here in an early photograph of club members. (Courtesy of the Stone Mountain Woman's Club.)

The Masons were active in Stone Mountain as early as 1849 and were originally chartered as Stone Mountain Lodge No. 111. In 1903, a new charter was obtained, Lodge No. 449, and the organization held its meetings on the second floor of the Stone Mountain Bank on Main Street. The total membership in 1939 was 45 men, and J.E. McClelland was the worshipful master. This active DeMolay order of young men, photographed in the Masonic lodge in 1948, included, from left to right, (first row) Thomas Lanford, Claude Bennett, Roy Mitchell, Victor Mullennix, four unidentified, and Vergil Mullennix; (second row) Bennie Gouge, Randolph New, three unidentified, Pete Autrey, Jimmy Pounds, and unidentified; (third row) two unidentified, Rufus Foster, two unidentified, Charles Wade, Bobby Mobley, David Wade, Charles Lanford, Sam Mobley, and Gene Bennett; (fourth row) Robert Holley, Chester Haynie, W.T. Thomas, Rev. Jack Nichols, Tom Rawlins, and five unidentified. (Photograph by John Fred Maddox; courtesy of the Coletti family.)

"Come Kill Depression!" Elias Nour, alias "Driver Wild Man," presented a Sunday afternoon spectacle in the 1930s, driving his car, "Depression," up the mountain, setting it on fire, jumping out, and then watching it sail over the edge to the cheers of his audience below. Marie Nour, Elias's mother, is seen here in the driver seat. (Courtesy of the Coletti family.)

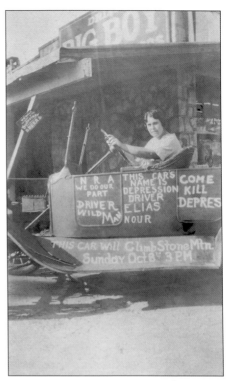

Stone Mountain's rock gymnasium was built with federal aid under Pres. Franklin D. Roosevelt's New Deal in 1936 and constructed by local stonecutters and masons, white and black. The photograph below shows the construction, which was supervised by a local committee made up of W.P. Humphreys, W.V. Murrow, T.S. Wells, D.N. McCurdy, and J.H. Griffin. The cornerstone notes Jesse A. Wilson as the architect. Hugh Jordan, a son of one of the stonecutters, stated, "Every stonecutter was out of work and they needed that job. We had fathers, uncles, and brothers who all worked on that building, and they were very proud of it." (Courtesy of the Hargrett Rare Book and Manuscript Library, University of Georgia Libraries; WPA Collection, DeKalb County).

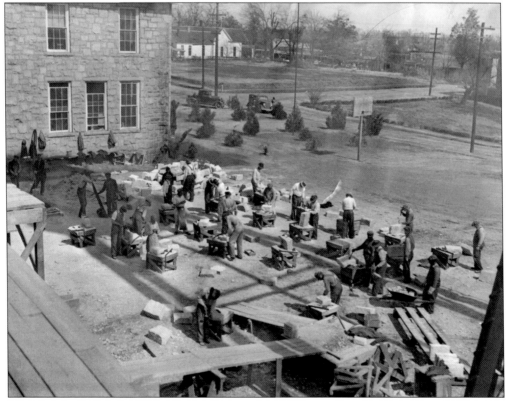

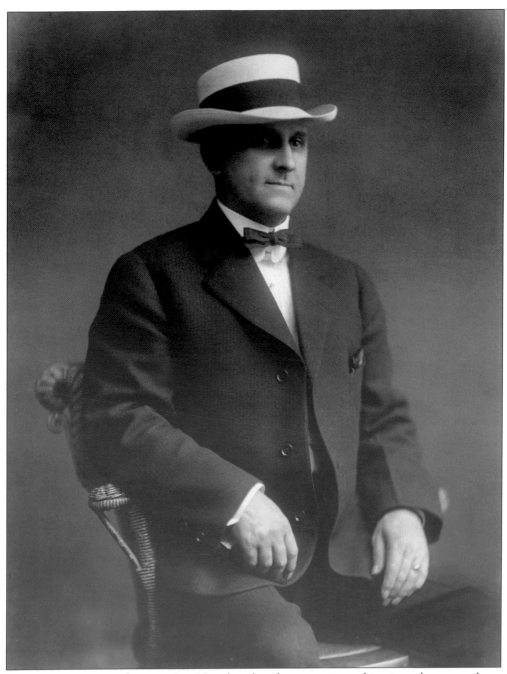

Jesse A. Wilson is seen here in 1941. He is listed in the census as working in real estate and was an avid photographer. He also knew enough about architecture to design the simply built and beautifully lit granite gymnasium. (Courtesy of the Mills family.)

The Progressive Club, formed in 1939 and bolstered by the efforts of the Stone Mountain Woman's Club, became an active force in modernizing the town. Main Street storefronts and telegraph poles were targeted, as well as crooked mailboxes. The new mayor, Marion Guess, and Doug McCurdy, the president of the new club, joined forces with the city council to grow public interest. Club officers included Steve A. Wells and C.T. Bagwell, and directors included Steve Wells, H.H. Dillard, T.S. Wells, J.C. Almand, J.T. Street, J.D. McCurdy, A.G. Spain, Dr. Willis McCurdy, F.C. Miller, E.A. Sexton, J.C. Jordan, W.K. Weatherly, and Julian Harris. (Courtesy of Jim McCurdy.)

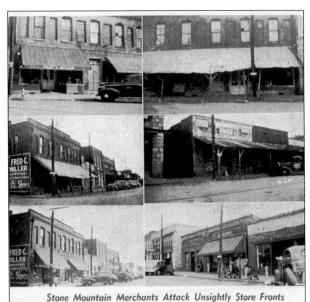

Stone Mountain Merchants Attack Unsightly Store Fronts

Tired of carrying on business in dimly lit stores, cut off from sunlight by old-fashioned metal awnings, Stone Mountain mer he suggestion of the new Progressive Club, attacked their store fronts with hammer and tongs, ripping down the aged eye sores, a hem with modern awnings and fresh white paint. Here are three typical scenes, before and after the work was undertaken. A nd right, is a comparison of the same building, before and after new awnings were put up. Center left, and lower left, we loo ain street of the city, which provides another excellent example of what the project accomplished. Right center, and lower right, ime shot of a group of stores as they once were and as they appear today. Note the Rogers sign, which has been moved back a uilding in the lower picture.

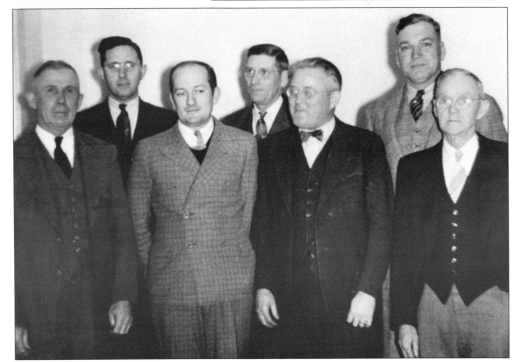

According to a 1939 article in the *DeKalb New Era*, "Stone Mountain city council is a public spirited body, ready to help in anything for the betterment of the community." The retiring and new members seen here in 1939 included, from left to right, J.M. Bagwell, former mayor; T.E. Rawlins, former councilman; Marion Guess, new mayor; W.E. Sexton, new councilman; J.D. McCurdy, clerk; J.T. Street, new councilman; and C.T. Gillam, new councilman. (Courtesy of Dorothy Guess.)

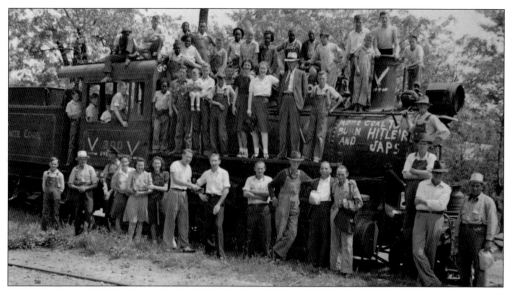

With the quarries no longer producing, the Dinkey was no longer needed. Plans were made to send it to Tennessee to be reconditioned for wartime use in the mines. The rails were also to be torn up and used for the war effort. Patriotic fervor led to the painting of wartime sentiments on the engine and, in Stone Mountain fashion, this end of an era was marked with a last ride. Stone Mountain folks, young and old, black and white, showed up for this last photograph with the Dinkey. (Photograph by John Fred Maddox; courtesy of the Coletti family.)

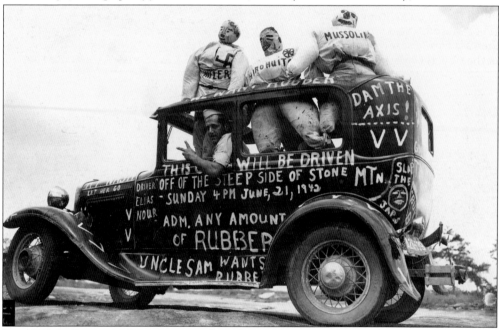

The "Kill the Depression" car event must have been a success, as Elias Nour turned his automobile folk art creativity toward Germany and Japan a few years later. His "Uncle Sam Wants Rubber" car event involved a car branded with wartime incantations such as "Dam the Axis!" and filled with stuffed figures representing Hitler, Mussolini, and Hirohito being launched off the steep side of the mountain on Sunday, June 21, 1942, at 4:00 p.m. (Courtesy of the Coletti family.)

A huge stuffed "Hitler" effigy was made and brought to downtown Atlanta for display by Elias Nour, seen here between the legs of the figure, and other Stone Mountain cohorts. (Courtesy of the Coletti family.)

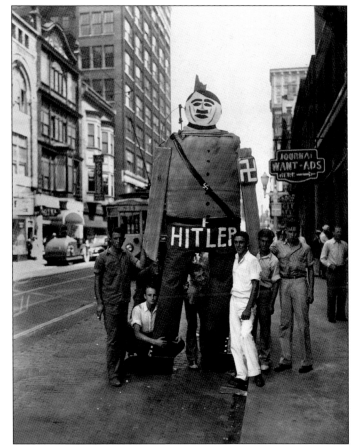

The center of town became a collection area for scrap metal for the wartime effort. Town children, many in bare feet, are seen below in a patriotic pose with a raised flag on Main Street. (Photograph by John Fred Maddox; courtesy of the Coletti family.)

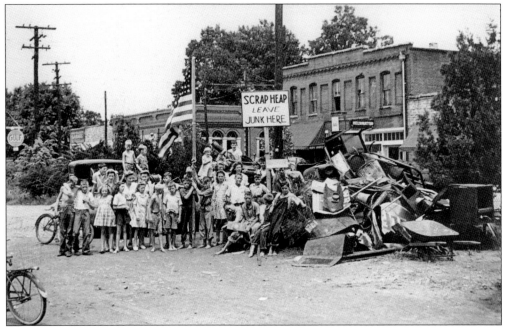

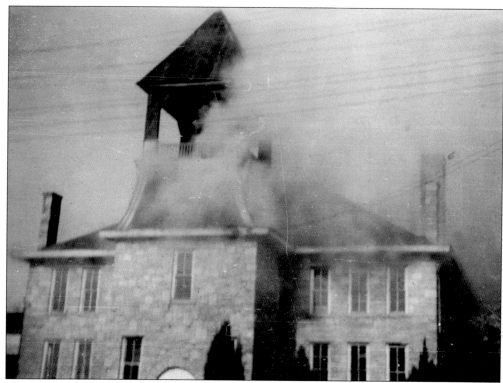

On April 16, 1943, a 15-year-old Joe Tucker took his camera to school and captured these images of the much-loved Stone Mountain Public School being destroyed by fire. (Both courtesy of Gary Peet.)

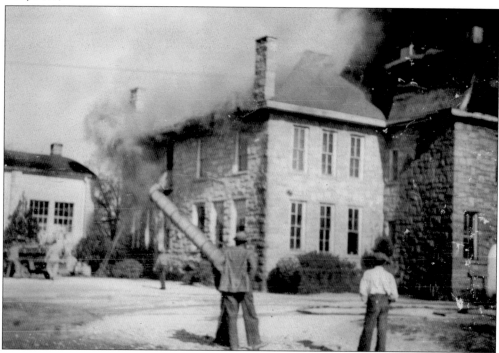

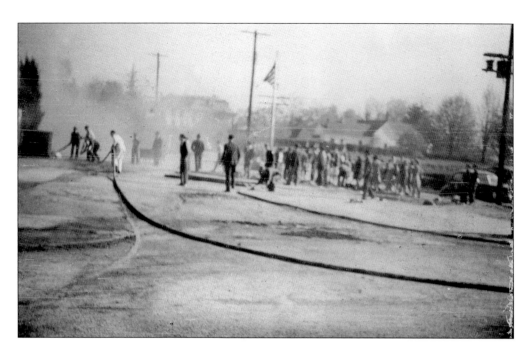

Smoke poured out of the bell tower and, despite the town's efforts, the building was lost. This series of photographs captured the dramatic event. Joe Tucker's photograph of the destroyed school made the front page of the *Atlanta Journal-Constitution*. (Both courtesy of Gary Peet.)

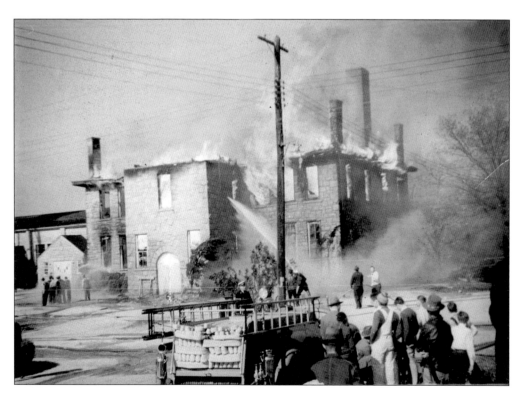

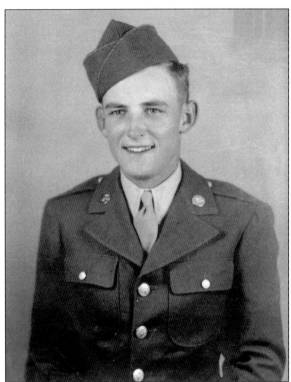

Many young Stone Mountain men served in World War II, and portraits were made of them in their uniforms. Bill Evans, seen here, fought at the Battle of the Bulge and returned to his family and home community. (Courtesy of JoAnn Florence.)

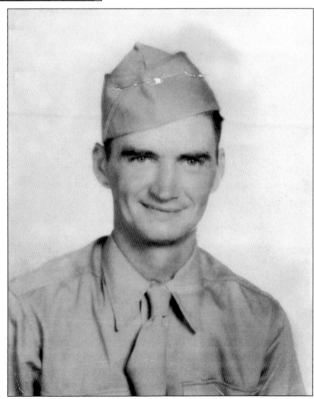

Pvt. Walter J. Ogletree, a young husband and father, was killed in action in Germany on November 30, 1944. (Courtesy of the Ogletree family.)

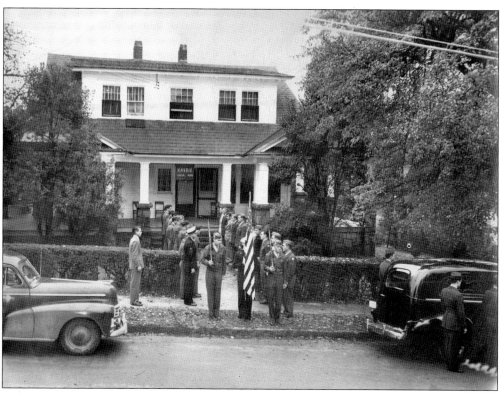

Ogletree's funeral, conducted by Stone Mountain's Veterans of Foreign Wars (VFW) Post 5257, was a solemn event in the town. (Both courtesy of the Ogletree family.)

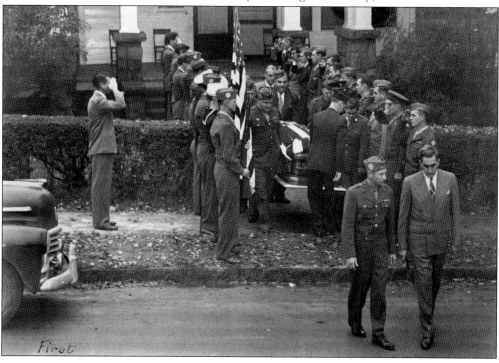

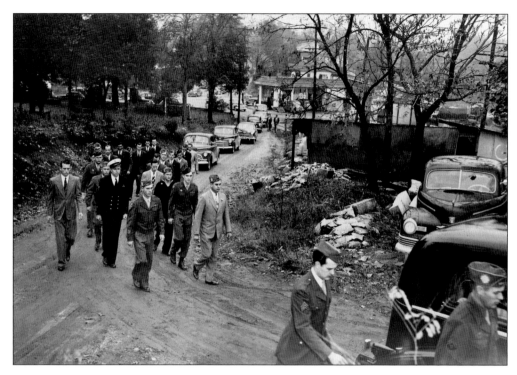

Walter Ogletree's funeral procession traveled down Main Street to the city cemetery, where he was buried. The VFW post was named after him for his service to his country. (Both courtesy of the Ogletree family.)

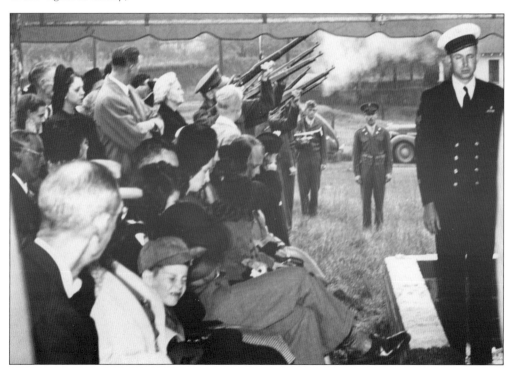

The trolley continued to serve the Stone Mountain community through the war, and conductors like Cleve Nix, seen here, were well known to riders. (Courtesy of the Hamby family.)

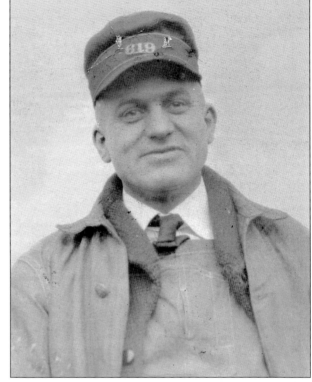

The romantic, noisy streetcar era came to an end in the late 1940s, when buses began to replace the older streetcar system and more residents had personal vehicles. Photographs like the one below captured passengers on "final" rides. (Courtesy of the Colleti family.)

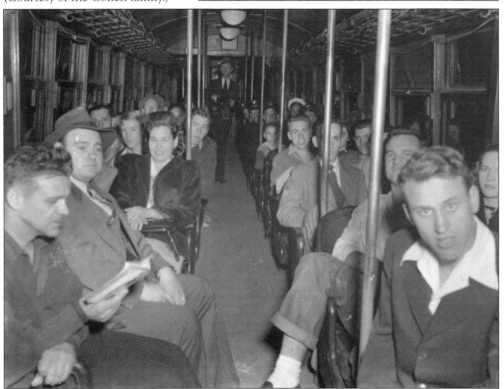

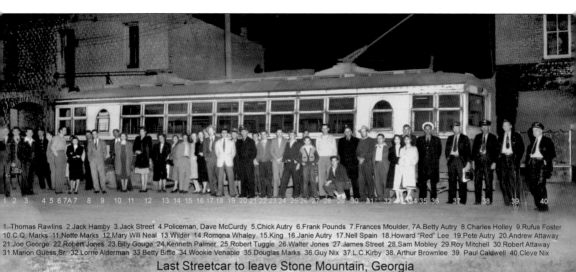

1.Thomas Rawlins 2.Jack Hamby 3.Jack Street 4.Policeman, Dave McCurdy 5.Chick Autry 6.Frank Pounds 7.Frances Moulder, 7A.Betty Autry 8.Charles Holley 9.Rufus Foster 10.C.Q. Marks 11.Nette Marks 12.Mary Will Neal 13.Wilder 14.Romona Whaley 15.King 16.Janie Autry 17.Nell Spain 18.Howard "Red" Lee 19.Pete Autry 20.Andrew Attaway 21.Joe George 22.Robert Jones 23.Billy Gouge 24.Kenneth Palmer 25.Robert Tuggle 26.Walter Jones 27.James Street 28.Sam Mobley 29.Roy Mitchell 30.Robert Attaway 31.Marion Guess,Sr. 32.Lorrie Alderman 33.Betty Biffle 34.Wookie Venable 35.Douglas Marks 36.Guy Nix 37.L.C.Kirby 38. Arthur Brownlee 39. Paul Caldwell 40.Cleve Nix

Last Streetcar to leave Stone Mountain, Georgia
13, March 1948
Historcal information compiled by:
Mrs. Charlotte Pittard & Dr. George Coletti

As in other communities, Stone Mountain residents turned out in droves to commemorate the last streetcar to leave the city, in 1948. (Photograph by John Fred Maddox; courtesy of the Coletti family.)

Seven

SMALL-TOWN LIFE

From backroom conversations at Mountain Pharmacy to parades on Main Street to each graduation day and birthday party, Stone Mountain exuded small-town charm, a can-do spirit, and strong family bonds. Each Wednesday at noon, the siren on top of city hall would blow, stores would close, and commerce would wind down for the afternoon. The Halloween festival was much anticipated, as was the Second Saturday in May, a holdover from early market days in the city. Tom Thumb wedding pageants were popular through the 1950s, and proms sometimes included climbing up the water tower by the rock gymnasium. The Stone Mountain Pirates, the high school basketball team, also won a state championship during that era, pleasing their devoted fans.

The small town eventually began changing. The opening of a supermarket would draw thousands who were curious to see what such a store would offer. Radio and television became a reality, and the city gained a movie theater. Stone Mountain High School, which had a graduating class of nine students in 1916, graduated 39 in 1950.

Stone Mountain was a segregated city, and Shermantown residents had their own school, lodges, and businesses. The African American neighborhood enjoyed some of the most beautiful views of the mountain. The trolley made it possible for many residents to find a wider range of jobs in Atlanta and Decatur and also opened up a way for many to attend college at Atlanta's historically black colleges and universities. Baseball was extremely popular, both organized games and sandlot games, and two local men went on to play for the Kansas City Monarchs of the Negro Leagues with legendary pitcher Satchel Paige.

After World War II, personal cars and buses put the trolley out of business. The demise of the trolley was marked by various events, as residents saluted the much-loved streetcar era. The 1950s were prosperous, and the city looked forward to the second half of the century.

This photograph, titled "Some Boys Around Town," captures Hill Tuggle holding court in his pajamas at the corner of Main and East Mountain Streets around 1940. From left to right are (first row) Dean Rhodes, Arthur Spain, Hilliard "Hill" Cherry Tuggle, Fred C. Miller, Gene Gilliam, Charlie Gilliam, and Gene Shinn; (second row) Howard Williams, Shelly Goldsmith, and Duval "Bebe" Tuggle; (third row) Gene Shin, Tom McConnell, Howard P. Tuggle, unidentified, Bill Lacey, John Haynie, Herman "Gippy" Gibson, and Dave McCurdy. (Courtesy of Tug Tuggle.)

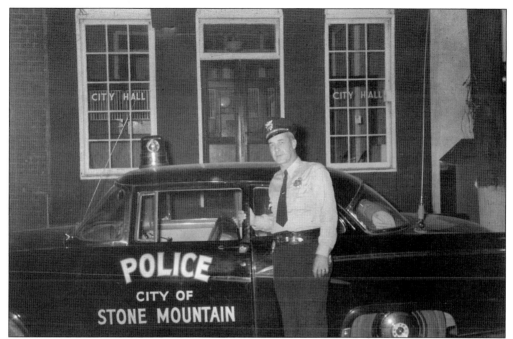

City hall was moved sometime after 1925 to East Mountain Street, into a building that had previously housed an undertaking business. After an emergency horn was mounted on the roof and "City Hall" was painted on the arched windows, it was open for business. Police chief Charles Thompson, who served 32 years on the force, is seen here in front of the building in 1956. (Courtesy of Pauline Myers.)

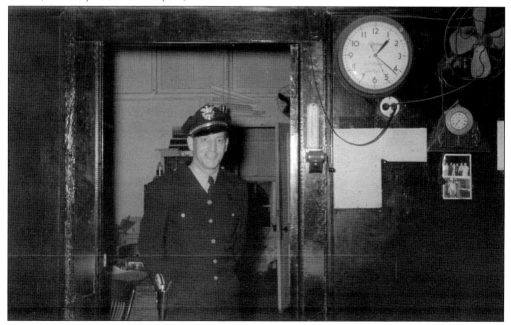

Offices, presumably for the mayor and the police, were located to the rear of the building, behind a second wooden partition. Officer Jack Payne, with his hat set at a jaunty angle, is seen here standing by the rear door. (Courtesy of Pauline Myers.)

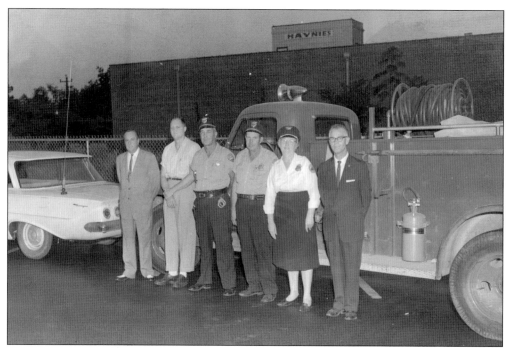

Stone Mountain's emergency personnel posed for this photograph around 1950 with Mayor Randolph Medlock in front of the city fire truck, located behind the old trolley barn. From left to right are John Steve McCurdy, Fred King, police chief Charles Thompson, Van Nelms, unidentified, and Mayor Medlock. (Courtesy of Pauline Myers.)

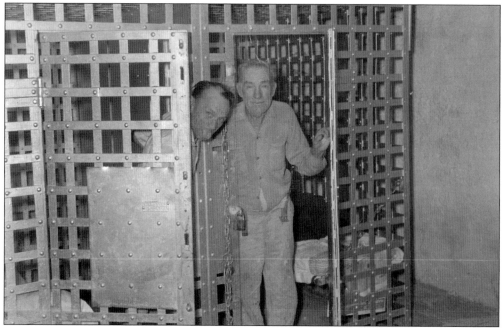

In Mayberry-like fashion, the old granite jail's interior was outfitted simply, with just a few cells. Two denizens are seen here posing for the camera in 1956. Shelley Goldsmith is on the left sticking out his tongue. (Courtesy of Pauline Myers.)

Police chief Charles Tucker served the city in law enforcement and then public works before joining the team in charge of carving the Confederate Memorial in the 1960s. (Courtesy of Gary Peet.)

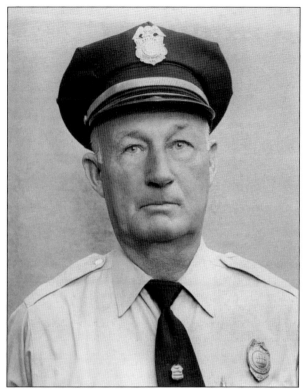

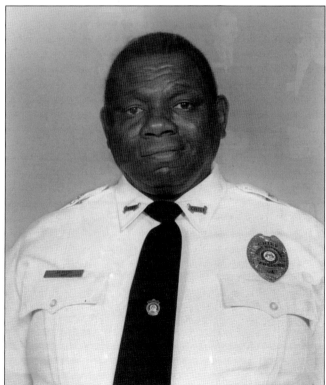

Police chief James B. Rivers worked on the force from 1956 to 1995. He began his career as a garbage collector for the city and eventually became chief of police. (Courtesy of the City of Stone Mountain.)

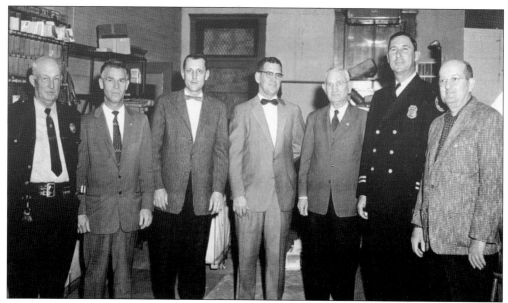

Chester S. Haynie, the mail carrier for rural route 2, and H.H. Elliot, the carrier for rural route 1, were awarded the National Safety Council Safe Driving Award in a city hall ceremony around 1945. Seen here at the ceremony are, from left to right, police chief Charles J. Tucker, Stone Mountain mayor Randolph Medlock, postmaster Robert Holley, Haynie, Elliot, DeKalb chief of police Brady Knight, and city clerk Marion Guess. (Courtesy of the Sanders family.)

Gathering at the Masonic lodge to present a retirement gift to ex-mayor Julian Harris are, from left to right, Kingsley Weatherly, Randolph Medlock, Harris, Margaret Harris, and Lucille and Douglas McCurdy. (Courtesy of the Rhodes family.)

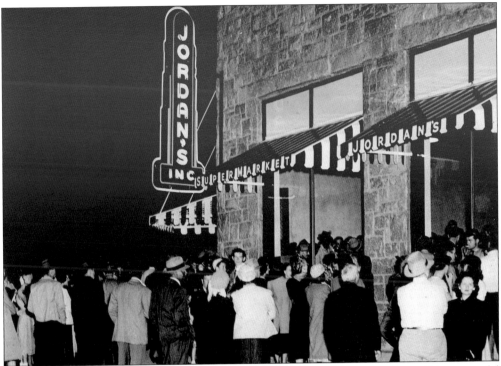

The opening of Jordan's Supermarket on Mountain Street in 1949 was an incredibly successful event, with thousands in attendance. (Both photographs by John Fred Maddox; courtesy of George Ann Hoffman.)

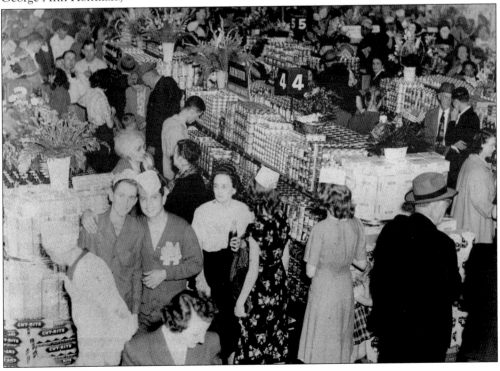

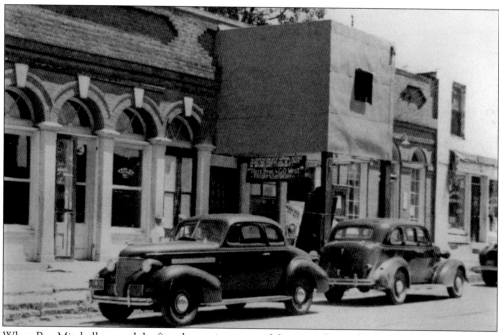

When Roy Mitchell opened the first theater in town on Mountain Street, he discovered that he needed a longer building to adequately project film. Demonstrating a can-do spirit, he built out a "projection box" over Mountain Street, right through the brick facade. (Courtesy of Gary Peet.)

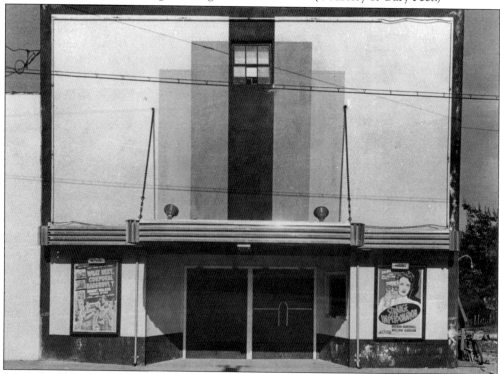

The second Mitchell Theater, located on Main Street, had an art deco exterior, a slanting floor, and a gallery for black patrons that was accessed from a side door. (Courtesy of Gary Peet.)

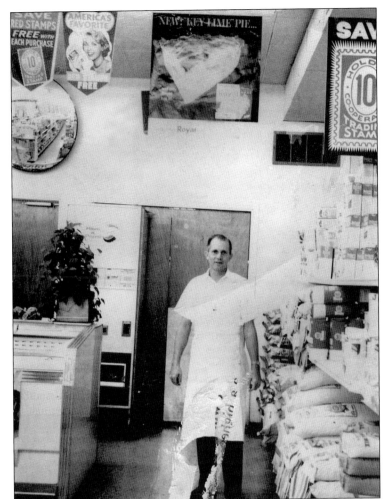

Sam and Ralph Hewatt managed Hewatt's Supermarket on Mountain Street before moving to lower Main Street, where they operated a "classic small town grocery" for over 30 years. Samuel Jefferson Hewatt is seen at right at work in the lower Main Street store, which served all citizens. (Both courtesy of the Hewatt-Cumbie family.)

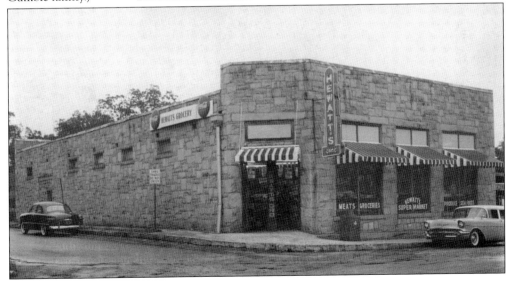

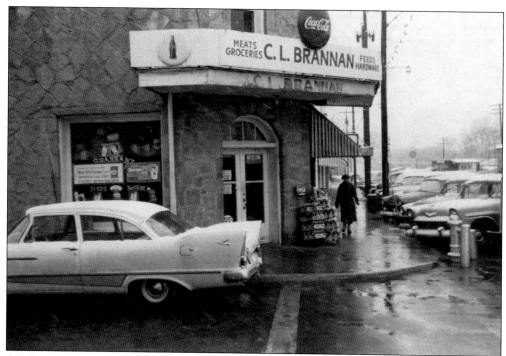

C.L. Brannon's grocery was a fixture in the granite building at the corner of Main and Manor Streets. The upstairs served as the city's telephone exchange in the 1920s. (Courtesy of the Wade family.)

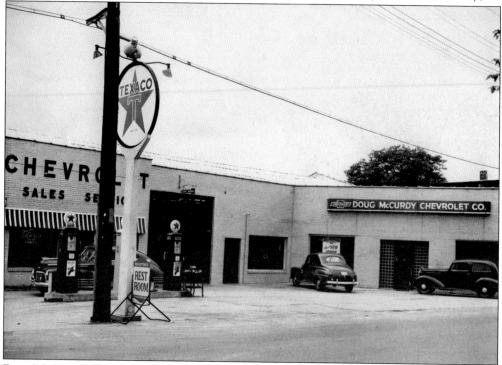

Doug McCurdy's Chevrolet dealership and Big Rock Service Station occupied almost a full block on Mountain Street in the 1950s. (Courtesy of the Wade family.)

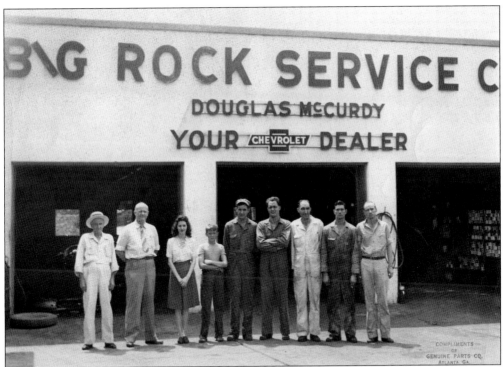

Genuine Parts Company of Atlanta sent a photographer to the McCurdy dealership to take this photograph of the staff around 1955. From left to right are unidentified, Doug McCurdy, Thelma Street, Buddy McCurdy, unidentified, Fred King, Pete Mullennix, Charlie Flowers, and ? Martin. (Courtesy of the Wade family.)

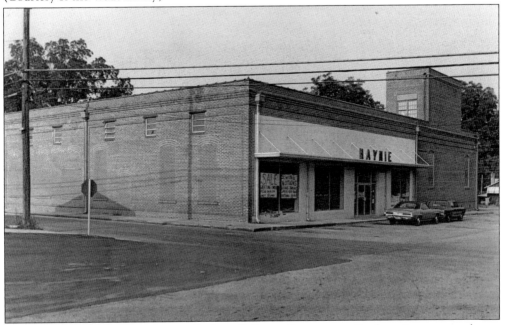

Hugh Jordan converted the Georgia Railway & Power Company trolley barn into a general store called Haynie's in the late 1950s. (Courtesy of the Jordan family.)

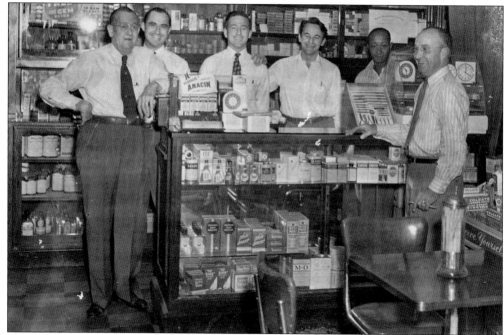

Mountain Pharmacy was an institution on Main Street, having been in operation since 1915. Davis Pittard, Jack Pittard, Chick Autry, and Joe Livesy staffed the popular drugstore, which included a row of old theater seats in front of the television in the back room that served as a community hub. Seen here sharing a laugh are, from left to right, Dr. Rufus Spinks, Davis Pittard, John "Jack" Pittard, Charles "Chick" Autry, Joe Livesey, and Dr. John Harris. (Courtesy of the Stone Mountain Historical Society.)

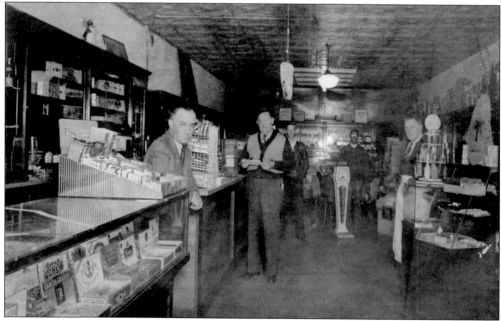

This early view shows the drugstore's original interior and layout. Dr. John Harris is between the counters in the left foreground. (Courtesy of the Stone Mountain Historical Society.)

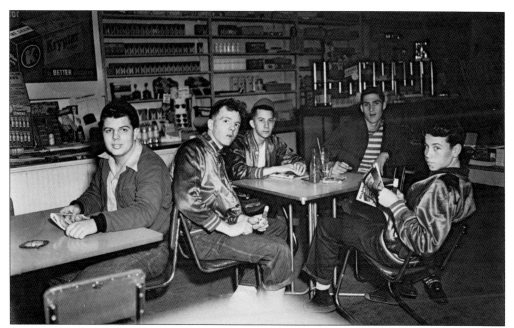

Maddox's Drug Store was also a Stone Mountain institution, with its soda fountain and selection of comics and magazines. Seen here from left to right are Billy Cabe, James Britt, Arlie Hitt, James Greer, and Spanky Wade. (Photograph by John Fred Maddox; courtesy of the Coletti family.)

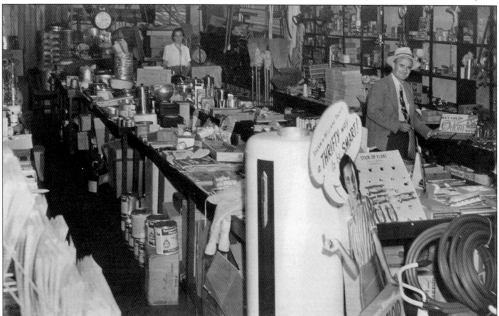

Pete Tuggle's hardware store was filled to the gills with everything anyone might need. Tuggle and clerk Rene Hicks are seen here in the store. A sign in the window announced: "This building ain't for sale or rent. It's been reserved for . . . 1- Hanging around in 2; Telling jokes in (If you know one, come on in); 3. Chewing tobacco in; 4. Swap fishing yarns; 5. Cussing politicians; 6. Telling white lies; 7. Taking cat naps; 8. Solving International Problems. Hours: Open when it suits. Closed: Whenever we get ready. Welcome!" (Courtesy of the Stone Mountain Historical Society.)

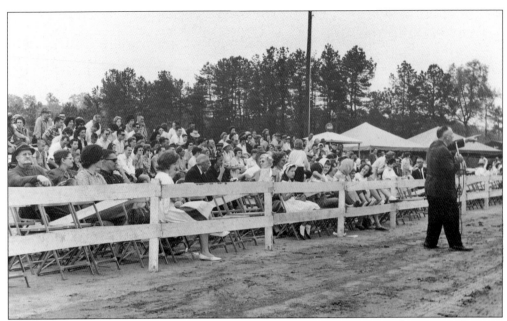

The Stone Mountain Woman's Club's horse show became a must-see event for area residents, as seen in this photograph of the 1963 show. (Courtesy of the Sanders family.)

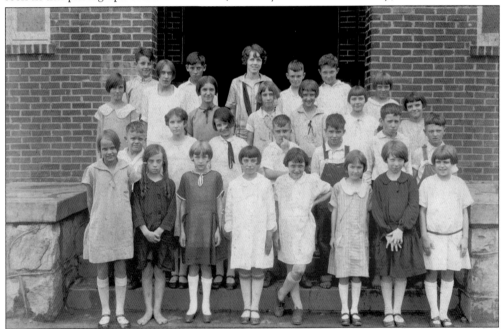

The 1927 fifth-grade class at Stone Mountain Elementary School, seen here on the school's entry stairs, included, from left to right, (first row) Dorothy Goldsmith, Pearl Fields, Sarah Sheppard, Frances Wade, Mary King, unidentified, Mildred Hicks, and Dorothy Williams; (second row) Billy Rankin, Ezma Whaley, Lois Lunsford, Bernard Dempsey, Louise Bradfield, Elbert Pearce, and Calvin Bowman; (third row) Mamie Ruth Spain, Viola Wallace, Mattie Powell, Rose Marie Pittman, Ola Mith, Dorothy Whaley, Bill Spain, and Mary Harvey; (fourth row) Jacob Cristopher, Elmer Richardson, Lucile Carswell (teacher), Hugh Mason, and ? Paris. (Courtesy of Dorothy Guess.)

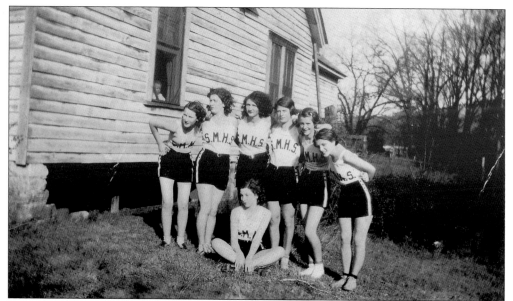

Stone Mountain High School's 1933 girls' basketball team gathered for this photograph in the Hicks's side yard, sporting their cutting-edge uniforms. The previous year, the team had worn bloomers. Captain Mildred Bagwell Hicks is seated on the ground. Standing behind her are, from left to right, Florence Kinnett Medlock, Francis Burt Nix, Isla Allen King, Eleanor Murdoch, Avis Chewning Wade, and Dorothy Williams Guess. Jo Anne Hicks is in the window. (Courtesy of Dorothy Guess.)

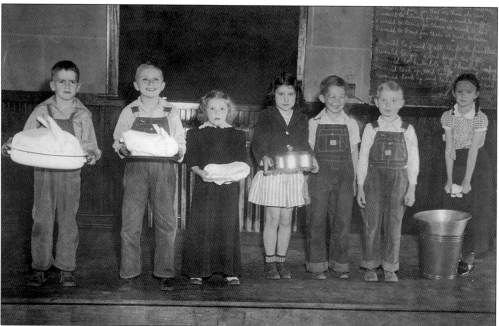

Holding a cornucopia of food, these youngsters were actors in a Thanksgiving play at the elementary school around 1940. They are, from left to right, George Dingler, Howell Hamby, Amelia Pinckard Butler, unidentified, Bill Hadaway, Julian Bean, and Ann Freeman Campbell. (Courtesy of the Hamby family.)

The Stone Mountain High School class of 1940, posing on the steps of the old granite school building, included, from left to right, (first row) Peggy Tucker, Pauline Wade, Leon Flowers, Sara Bailey, Lois Wade, and Margaret Smith; (second row) Sara Phipps and Catherine King; (third row) Myra Sue Mitchell, Mary Johnson, Nour A. Nour, Esther Fields, and Louise Bailey; (fourth row) Weldon Scroggs, Verna Mobley, Lanford Jordan, and Walter Woodruff; (fifth row) Thomas Rice, Robert Mullennix, Etta Ergle, and Edwin Scroggs. Not pictured are Cornelia Kellersberger and J.R. King. (Courtesy of Gary Peet.)

The class of 1950, assembled on the rock gymnasium's stage, which is decorated with magnolia leaves, included, from left to right, (first row) Annette Young, Lowe Deaton, Jane Phillips, Chuck Britt, Peggy Haymie, Jake Rutledge, mascot Mary Jane McCurdy, Annette Mize, Thomas Lanford, Alice McCurdy, Jerry Baxter, Laura Saudent, Millie Lunsford, and Dave Wilson; (second row) G.L. Brookshire, Geraldine Leach, Johnny Ivey, Doris Hewatt, Billy Cabe, Joyce Crone, G.W. Crone, Martha Wages, Annie Smith, Ronald Rowland, June Malcom, Howard Gouge, and Mary McCurdy; (third row) Roy Mitchell, Barbara Rankin, Billy King, Gwen Dilbeck, Paul Slaughter, Carolyn McCurdy, Claude Bennett, John Hewatt, Alice Freeman, Betty Jane Vaughn, Charles Mize, Jacolyn Rawlins, Kenneth Nunnally, Frances Gouge, Stewart Butler, and Ruby Dunn. (Courtesy of the Stone Mountain Historical Society.)

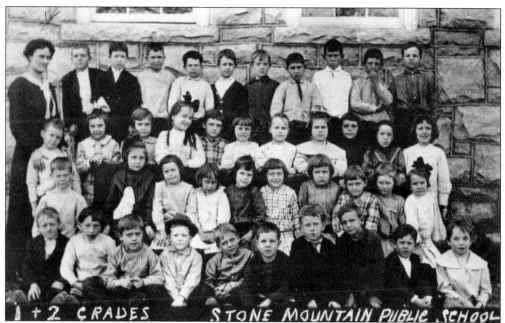

1 + 2 GRADES STONE MOUNTAIN PUBLIC SCHOOL

Georgia Simmons is seen above in the upper left with her first- and second-grade class at Stone Mountain Public School. The teacher went on to be an actress, appearing in films such as *Tobacco Road*, *Cleopatra*, and *The Rose Tattoo*. She returned to Stone Mountain often, to the delight of the community. (Courtesy of Jim McCurdy.)

Joe Tucker, seen here, made history with the first radio broadcast from Stone Mountain. (Courtesy of Gary Peet.)

Vivian Ogletree happily poses on the depot platform next to the train schedule around 1950. (Courtesy of the Ogletree family.)

Eva Jewell Greene moved to Stone Mountain in 1951 and began working for the betterment of the Shermantown community. She founded the Stone Mountain Negro Civic League and served as its president for approximately 25 years. She was instrumental in establishing the DeKalb Economic Opportunity Authority in 1966 and would later serve on the county's bicentennial commission. (Courtesy of the Greene family.)

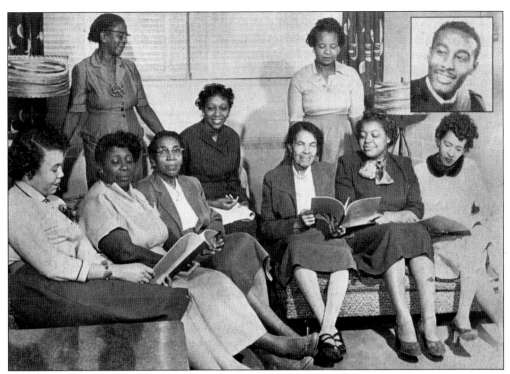

African American educators at the Victoria Simmons School in Shermantown gathered for the group photograph above around 1960. They are, from left to right, (seated) E. Mallory, Frances Maddox, Lula Harper, Narvie Harris, Ora Woods, Z. Stafford, and Ruby McClendon; (standing) Frances Dobbs and Jondelle Johnson. Edward Bouie Sr., seen in the inset in the upper right, served as both a teacher and the principal. Victoria Simmons School, a Georgia equalization school constructed in 1956, replaced an earlier school built with Rosenwald funding. (Courtesy of Narvie Jordan Harris.)

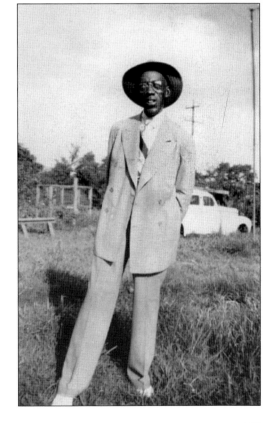

Deacon James "Hump" Reed, a Dinkey operator, is seen here. (Courtesy of the Stone Mountain Historical Society.)

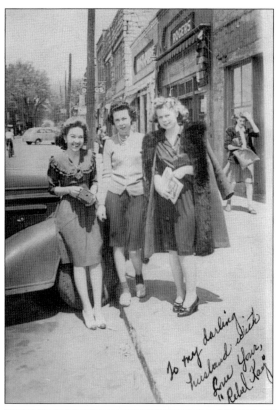

From left to right, Kathleen Mullennix, Peggy Grant, and Gordie Franklin pose for a photograph on Main Street in 1944. Signed as "Rebel Kay," the hometown photograph, which dates to World War II, was likely sent to Mullennix's husband, who was in the service. (Courtesy of the Mills family.)

Snow was a rare event in Stone Mountain, and 16-month-old Charles Tuggle's eyes say it all in the photograph below, particularly in contrast to Mrs. Nash's expression. The photograph was taken at the Nash house before it was relocated from Ridge Avenue to Forest Avenue. The Wells Brown house is in the background. (Courtesy of Tug Tuggle.)

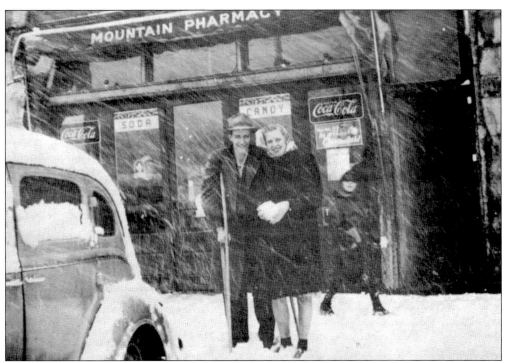

Above, Doug Autrey and Glenna Richardson braved a snowstorm to visit the Mountain Pharmacy. (Courtesy of the Coletti family.)

Dr. Charlie Tuggle Sr., the town dentist, stands with Bebe Tuggle in front of Tuggle Service Station, at the corner of Main and Mountain Streets. Dr. Tuggle's office was between the Methodist church and Main Street. (Courtesy of Tug Tuggle.)

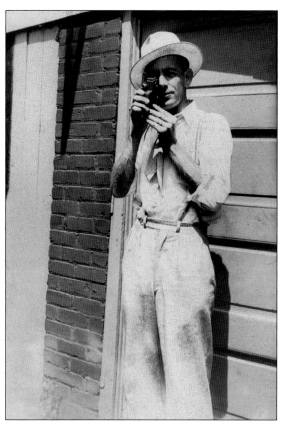

Photographer John Fred Maddox is captured here while taking a photograph himself. Maddox kept a photographic record of all things Stone Mountain. (Courtesy of the Coletti family.)

Stone Mountain had an African American baseball league in 1940, and many baseball fans went to watch games played in a field near Shermantown. The team included, from left to right, (kneeling) Harry Morris Jr., Flip Dempsey, unidentified, and Mr. Stewart; (standing) unidentified, J.C. Maddox, Joseph Smith, Robert Banks, unidentified, Alfred Hall, and unidentified. (Courtesy of the Stone Mountain Historical Society.)

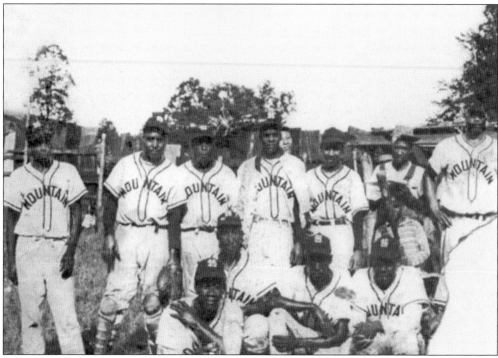

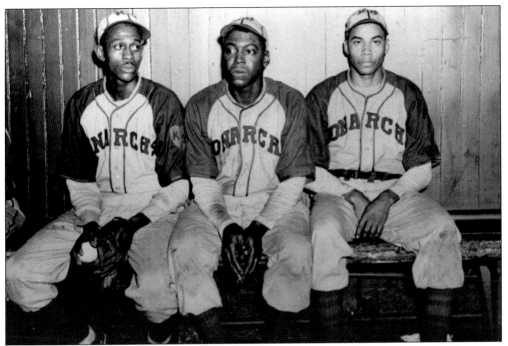

James Elbert Greene was born in Shermantown in 1911 and started his career as a first baseman with the Atlanta Black Crackers of the Negro Southern League in 1932. Considered by many to be the best catcher in the Negro Leagues, he was drafted during World War II but returned to the game, playing until 1948. He served with the 92nd Division in Algiers and Italy and spent months on the front lines. He played with the Homestead Grays in 1939, the Kansas City Monarchs from 1939 to 1943 and 1946 to 1947, the Cleveland Buckeyes in 1948, and in the minor leagues in 1951. Greene (center) is seen here with two Kansas City teammates, including legendary pitcher Satchel Page (left). (Courtesy of Richard Mailman.)

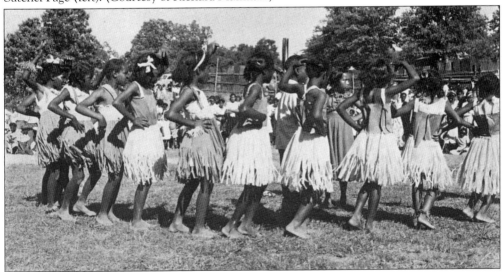

May Day activities at Victoria Simmons Elementary School are captured in this late 1950s photograph. A troupe of young dancers performs on the lawn for the community. (Courtesy of Narvie Jordan Harris.)

The Depression-era rock gymnasium hosted all high school events, from graduations to basketball games to plays. Here Ann Smith, a top-notch drum majorette, shows off her skills. (Courtesy of the Hamby family.)

In 1957, the Stone Mountain Pirates, under coach E.L. "Cobby" Rainey, won the first state tournament basketball game the school ever competed in. Ronnie Spain, Jimmy Pulliam, Ted Snow, Phil Ashe, and Ottis Phillis made history for the team while their teammates and coaches cheered them on. Seen here from left to right are Jerry Thompson, Fred Crow, Jimmy Pulliam, Gary Bradberry, Ronnie Patway, Douglas Roberts, coach Cobby Rainey, and coach John McPherson. (Courtesy of the Phillips family.)

Go Pirates! Annette Haney Slaughter wore number 13 on the Stone Mountain High School girls' basketball team in the early 1950s, when both the girls' and boys' Pirate teams put Stone Mountain on the map with their prowess. (Courtesy of Annette Haney Slaughter.)

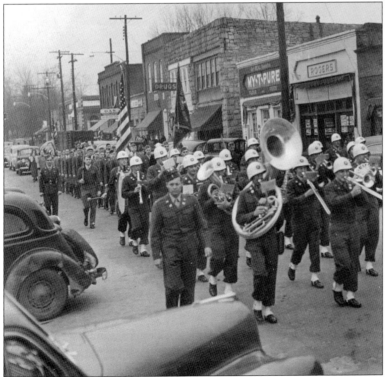

Marching bands and parades, like this Veterans Day parade around 1950, became regular events on Main Street. Here, uniformed servicemen and ex-servicemen in street clothes follow the marching band down Main Street toward the depot. (Courtesy of the Ogletree family.)

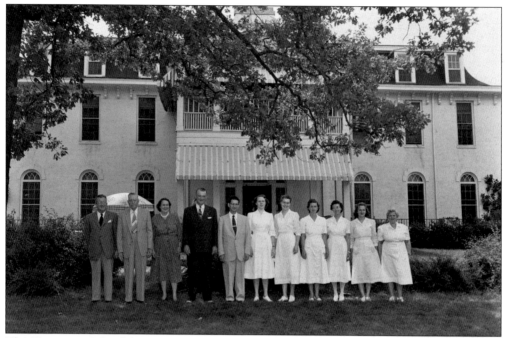

The University School for Boys property was converted into the Cheston King Sanitarium by 1924. In the 1940s, it was renamed Brook Haven Manor Sanitarium. Dr. Newdigate M. Owensby was the resident psychiatrist at the sanitarium, Dr. J. Rufus Evans and Dr. Willis T. McCurdy were the attending physicians, and Elizabeth Hancock was the psychotherapist. Room, board, and treatment were offered for $100 a week. This photograph from around 1965 shows owner Dr. Winston Burdine (fourth from left) and his wife posing with staff members in front of the main building. The building was destroyed by fire in the mid-1970s, and the ruins were totally removed in 1977. (Courtesy of Lane Brothers, Special Collections Department, Pullen Library, Georgia State University, LBCB-104-038a, LBCB-104-38b.)

Hugh and Betty Haynie Jordan, who married and moved into a mid-century home in Stone Mountain, typify the postwar generation. The Jordans eventually moved to the Parks subdivision, choosing a ranch-style home for their family. They are seen here in 1949 having dinner at the Empire Room in the Palmer House in Chicago. (Courtesy of the Jordan family.)

Ranch homes and small houses, some trimmed with granite, mushroomed on the city's outlying streets as young men and women settled back into small-town life after World War II. The Hewatt house, on Ferndale Road, with its stone trim, screened porch, and ample yard, was perfectly pitched with the mid-century residential aesthetic. It also had plenty of room for pony rides. Mary Ellen Hewatt Malone is seen at right on Star, a gift for her sixth or seventh birthday. (Both courtesy of the Hewatt-Cumbie family.)

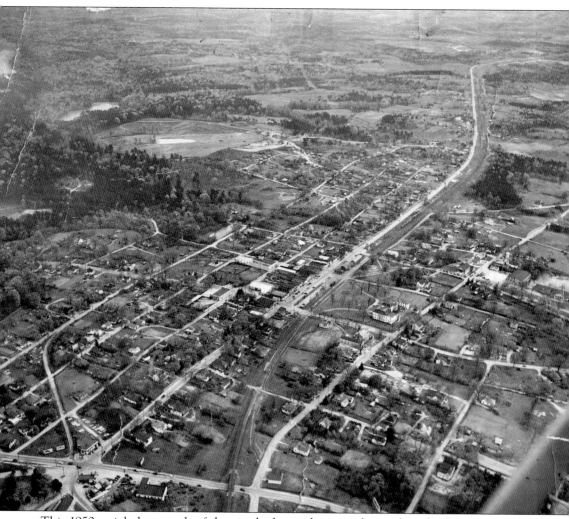

This 1950 aerial photograph of the city looks southwest and provides a bird's-eye view of its growth. The curving trolley line is still evident and the University School for Boys buildings are still standing. The downtown area is in the center. (Courtesy of Gary Peet.)

Eight

MODERN STONE MOUNTAIN

The prosperity of the 1950s continued, but with the expansion of metropolitan Atlanta eastward and the establishment of Stone Mountain Park in the city's backyard, Stone Mountain faced a number of challenges. The park put the city on a national stage, and the community wanted to be ready for what was coming. The city, underpinned by the Stone Mountain Woman's Club, began a cleanup campaign that touched everything from mailboxes to sprucing up the city cemetery. In time, Main Street's storefronts no longer housed groceries, pharmacies, or shoe stores, as craft stores, boutiques, and tourist attractions took their place.

Stone Mountain has expanded its borders, taking in adjacent subdivisions to the south and east. In 1996, the Olympic torch passed through Main Street on its path to the Atlanta Summer Games. The city dressed up for the occasion, beautifying its streets and painting faux bricks on its sidewalks. In the late 1980s, the trolley barn was converted into ART Station, a theater, gallery, and community centerpiece.

The civil rights movement created great change in the area, including school integration, and Stone Mountain's past as a Ku Klux Klan gathering place was indelibly sealed by Dr. Martin Luther King Jr.'s famous speech asking for freedom to ring from Stone Mountain. The 20th century closed with great demographic changes that brought African American families to Stone Mountain's suburban neighborhoods. Today, Stone Mountain reinvents itself once again in anticipation of its 175th anniversary.

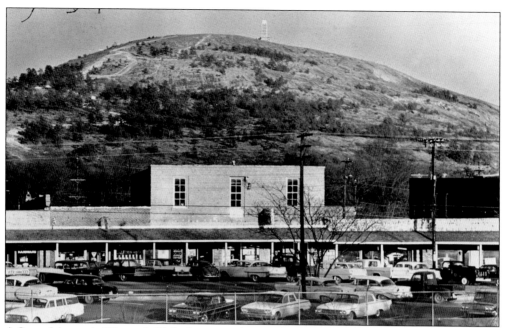

A Stone Mountain Woman's Club plan to modernize the city used this iconic graphic to get their point across. They led the charge by constructing a new clubhouse, sponsoring community cleanup days, and fostering community interest in change, along with other organizations. (Courtesy of the Stone Mountain Woman's Club.)

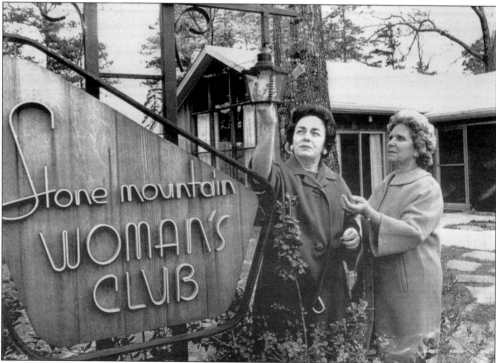

Lucille McCurdy and Mari Jo Ford admire the beautiful 1960s sign in front of the clubhouse. (Courtesy of the Stone Mountain Woman's Club.)

The Stone Mountain Woman's Club was able to "burn the mortgage" on its new club building in 1966. The $23,000 building on East Mountain Street featured modern design elements. Seen around the brazier are, from left to right, Sue Kellogg, Marie McClellan, Mari Jo Ford, Pat Smith, Evaline de Ovies, Margaret Weatherly, and Alice McCurdy. Outgoing president Lucille McCurdy is lighting the flame. (Courtesy of the Stone Mountain Woman's Club.)

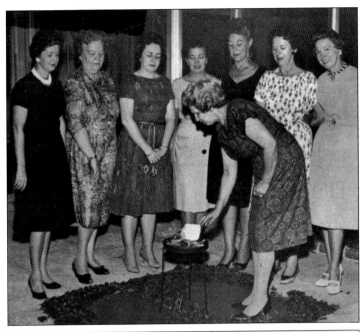

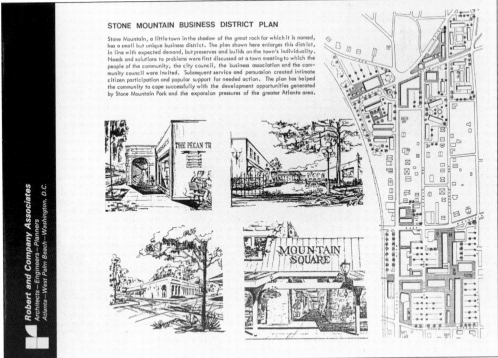

The club also garnered help from planner and landscape architect Andre Steiner of Robert and Company Associates, the firm responsible for the park's design, for this business district plan. Steiner set out some ambitious plans that were never completely followed, but two ideas emerged from his advice: the centralization of the jail and city hall in the then-vacant depot and the creation of a more pedestrian-friendly, mall-like atmosphere on Main Street. (Courtesy of the City of Stone Mountain.)

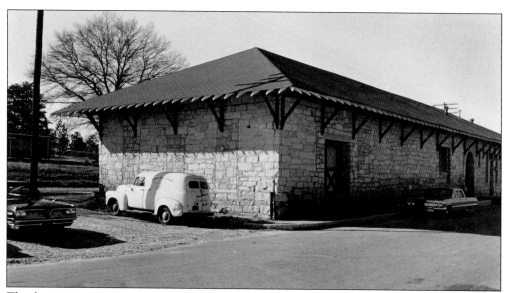

The depot, vacant since about 1952, was successfully converted into a new city hall in 1964, and the gazebo was added to the site in 1977. The southern, original end of the depot was adapted for reuse into a police department and jail in 1965. Police chief Charles Thompson and officers Jake Payne, Milton Spivey, and T.L. Collins volunteered their time to complete the conversion. Their efforts resulted in two large cells, a drunk tank, and separate facilities for female prisoners. (Courtesy of George Ann Hoffman.)

Steiner's idea to unify the Main Street block into one shopping area focused on the construction of a long masonry arcade or porch that would extend the length of the commercial block. Stone Mountain business owners and merchants took his idea and created a much less costly solution: this continuous shed-roof canopy over the sidewalk. Disliked by preservationists but loved by visitors and customers, the canopy stood on Main Street until 2011. (Courtesy of George Ann Hoffman.)

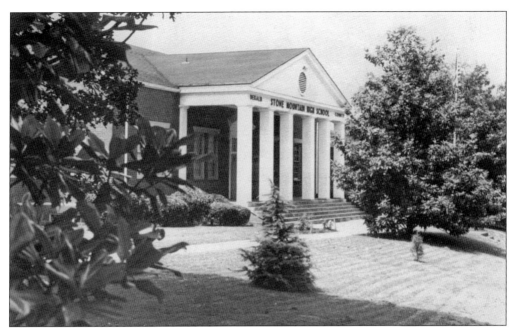

The new Stone Mountain High School (above) was built during this period, on the same block that had held the town's public school facilities since the 1800s. (Courtesy of Gary Peet.)

Stone Mountain Elementary School was built in phases on Memorial Drive near the developing Parks subdivision. Atlanta architects A. Thomas Bradbury and Ralph E. Slay were responsible for its design. The modern elements include the entry and the long classroom wing. The use of aluminum in the front entry was recognized in this advertising campaign, titled Cinderella '55, for Amarlite Aluminum Entrances. (Courtesy of the Stone Mountain Historical Society.)

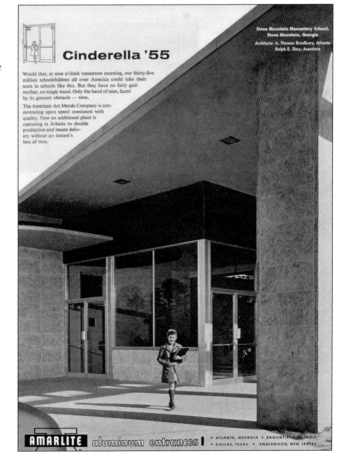

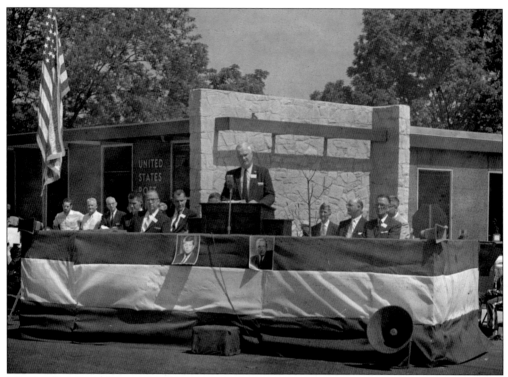

This modern post office with a distinctive stone facade was constructed on East Mountain Street in the early 1960s. The city marked it with the formal dedication seen here. From left to right are unidentified, Bevel Jones, Tom Rawlins, two unidentified, Robert Holley, Congressman James C. Davis (speaking), former judge and US representative Dudley Johnson, and two unidentified. (Courtesy of Gary Peet.)

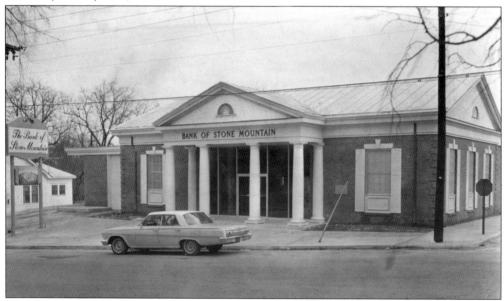

The Bank of Stone Mountain, located on East Mountain Street, was also added to the city's building stock. The building is currently occupied by SunTrust Bank. (Courtesy of Gary Peet.)

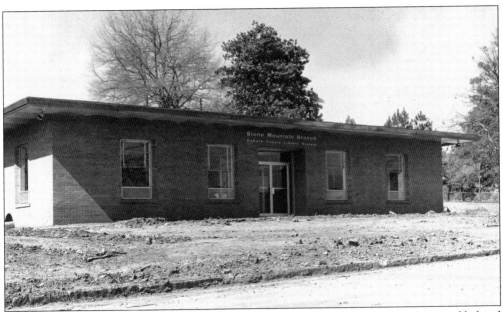

The first Stone Mountain branch of the DeKalb County Library System was constructed behind the city hall complex. It was later enlarged and named in honor of Stone Mountain community leader Sue Kellogg. (Courtesy of George Ann Hoffman.)

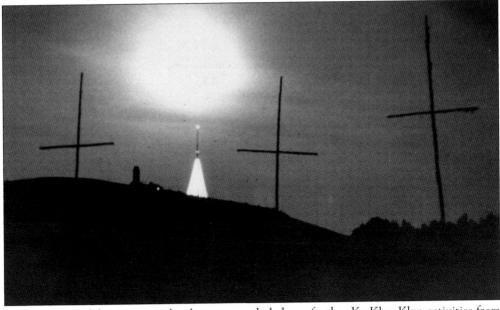

The purchase of the mountain by the state precluded any further Ku Klux Klan activities from occurring there. In response, James Venable, a Stone Mountain resident and the imperial wizard of the National Knights of the Klan from 1963 to 1987, shifted the group's activities to the city. The Klan would parade down Main Street and through the African American neighborhood of Shermantown to reach a field Venable still owned on the west side of the mountain, where rallies would take place. These crosses were photographed during the Christmas season, when a lighted tree was placed on the mountain's summit. (Photograph by George Coletti; courtesy of the Coletti family.)

Fourth of July parades became an annual event in 1983. Lucille McCurdy is seen here driving in a replica Bugatti in the first parade. (Courtesy of the Georgia Archives, Vanishing Georgia Collection, DEK-383-85.)

Parade watchers looked forward to seeing the children in the bicycle brigade with great anticipation. This throng of bike riders was part of a 1990s parade. (Courtesy of the Hollis family.)

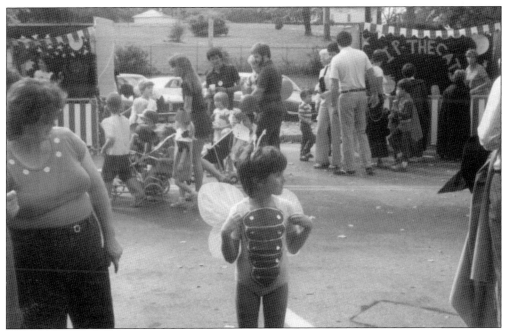

The Halloween festival was initially held at the rock gymnasium but later moved to Main Street, which was closed to traffic for the annual festival, enjoyed by both young and old. Mary White is shown here dressed as a butterfly in 1983. (Courtesy of Madeline White.)

The old trolley barn and power station was converted once again in 1987, when a $3.5 million campaign was launched to renovate the space into a contemporary arts center called ART Station. The name stems from a 1913 photograph of a trolley car in front of the building that had "Atlanta Rapid Transit" written on its side. On hand at the ribbon-cutting were, from left to right, Manuel Maloof, chief executive officer and commission chairman of DeKalb County; Jane Rhodes, Stone Mountain's first female mayor; David Thomas, artistic director and founder of ART Station; Betsy Weltner, executive director of the Georgia Council for the Arts; and Jo Hill, treasurer of the board of trustees of ART Station. (Courtesy of ART Station.)

The 1914 Seaboard Railroad cupola caboose above (No. 5506) was donated to the Village of Stone Mountain in 1988 by the Stone Mountain Memorial Association. It had been refurbished in 1963 for use as the first office of the Stone Mountain Scenic Railroad and was later used in the park as an office and break room for train conductors and actors before becoming a visitor center. (Courtesy of New South Associates.)

During the 1996 Atlanta Olympics, Stone Mountain Park and the area's sports venues hosted several events. Lucille McCurdy, a much-loved community leader, was chosen to carry the torch through the village. (Courtesy of the Sanders family.)

The city's first African American mayor, Charles "Chuck" Burris, who was elected in 1997, added a large cast-iron bell to Main Street's cityscape, signaling that freedom does ring from Stone Mountain. After it was installed, a new tradition of ringing the bell on Martin Luther King Jr. Day began. (Courtesy of Evelyn Hearns.)

Art that speaks to the history of the granite industry in Stone Mountain was added to Main Street as part of a streetscape project. This sculpture was designed and fabricated by artist Johnny Thigpen. (Courtesy of New South Associates.)

The city celebrated the Civil War sesquicentennial with the installation of the "Sherman's Necktie" display, conceived by Rusty Hamby, near the railroad at Main and Mountain Streets. (Photograph by George Coletti; courtesy of the Coletti family.)

This new masonry municipal building was completed in 2012 on Main Street, and future plans call for the rehabilitation of the now-vacant depot into a visitor center to welcome a whole new century of visitors to Stone Mountain. (Photograph by Terri Gillett; courtesy of New South Associates.)

Bibliography

"Clifford 'Connie' Johnson." Negro Leagues Baseball Museum e-Museum and Kansas State University College of Education. www.coe.ksu.edu. Accessed July 1, 2013.

Coletti, George D.N. *Stone Mountain: The Granite Sentinel.* Stone Mountain, GA: self-published, 2010.

Davis, Chris. *Confederate Veterans of Stone Mountain.* Stone Mountain, GA: Project of Confederate Memorial Camp 1432, 2000.

DeKalb New Era. Granite Highway Edition. Decatur, GA: J.O. Bell, May 28, 1914.

DeKalb New Era. Stone Mountain's 100th Anniversary Edition. Decatur, GA: December 21, 1939.

Flanigan, J.C. *History of Gwinnett County, Georgia 1818–1943.* Both volumes. Lawrenceville, GA: Gwinnett Historical Society, 1995.

Freeman, David. *Carved in Stone: The History of Stone Mountain.* Macon, GA: Mercer University Press, 1997.

Garrett, Franklin M. *Atlanta and Environs: A Chronicle of its People and Events.* Both volumes. Athens, GA: University of Georgia Press, 1954.

Georgia Highways. Vol. 5, No. 9. Georgia State Highway Department, 1927.

Holway, John. *Voices From the Great Black Baseball Leagues* (revised). New York: Dover Publications, 2012.

"Joe Greene." Negro Leagues Baseball Museum e-Museum and Kansas State University College of Education. www.coe.ksu.edu. Accessed July 1, 2013.

Mason, Herman "Skip" Jr. Images of America: *African-American Life in DeKalb County, 1823–1970.* Charleston, SC: Arcadia Publishing, 1998.

Miller, Theodora R. and I. Lamar Maffett Jr. *Historic Stone Mountain Village.* Stone Mountain, GA: Stone Mountain Press, 1976.

Patton, Kathryn. *A Sketchbook of Stone Mountain.* Stone Mountain, GA: Friends of Sue Kellogg Library, not dated.

Reed, Mary Beth. *Granite Quarrying at Stone Mountain, DeKalb County, Georgia, 1850–1978.* New South Associates Technical Report prepared for the Stone Mountain Memorial Association, 2002.

Reed, Mary Beth, J.W. Joseph, and Lisa M. Kehoe. *Historic Sites Survey, City of Stone Mountain, DeKalb County, Georgia.* New South Associates Technical Report prepared for the City of Stone Mountain, 1994.

Robert and Company Associates. Stone Mountain Business District Plan, not dated.

Stone Mountain First United Methodist Church. *History of Stone Mountain First United Methodist Church, 1854–2000.* Stone Mountain, GA: self-published, not dated.

Stone Mountain Woman's Club. *Stone Mountain: The City That Tackled a Mountain of Problems.* Stone Mountain, GA, not dated.

DISCOVER THOUSANDS OF LOCAL HISTORY BOOKS
FEATURING MILLIONS OF VINTAGE IMAGES

Arcadia Publishing, the leading local history publisher in the United States, is committed to making history accessible and meaningful through publishing books that celebrate and preserve the heritage of America's people and places.

Find more books like this at
www.arcadiapublishing.com

Search for your hometown history, your old stomping grounds, and even your favorite sports team.